Treasures of Barbados

Henry S. Fraser

President, Barbados National Trust

Photographs by
Felix Kerr, Willie Alleyne and
Henry Fraser

MACMILLAN
CARIBBEAN

© Copyright text Henry S. Fraser 1990
© Copyright illustrations The Macmillan Press Ltd 1990

All rights reserved. No reproduction, copy or transmission of
this publication may be made without written permission.

No paragraph of this publication may be reproduced, copied or
transmitted save with written permission or in accordance with
the provisions of the Copyright, Designs and Patents Act 1988,
or under the terms of any licence permitting limited copying issued
by the Copyright Licensing Agency, 90 Tottenham Court Road,
London W1P 9HE.

Any person who does any unauthorised act in relation to this
publication may be liable to criminal prosecution and civil
claims for damages.

First published 1990
Reprinted 1994

Published by THE MACMILLAN PRESS LTD
London and Basingstoke
*Associated companies and representatives in Accra,
Auckland, Delhi, Dublin, Gaborone, Hamburg, Harare,
Hong Kong, Kuala Lumpur, Lagos, Manzini, Melbourne,
Mexico City, Nairobi, New York, Singapore, Tokyo*

ISBN 0-333-53369-0

Photoset by Parker Typesetting Service, Leicester

Printed in Hong Kong

A catalogue record for this book is available from
the British Library.

Cover illustrations:
Front cover: A well crafted house
with a pedimented porch.
(Felix Kerr)
The Barbados Museum –
originally the Military Prison.
(Felix Kerr)
St. John's Church
(Willie Alleyne)
Back cover: The quintessential
Bajan cottage – forgotten
treasure.
(Henry Fraser)

Contents

	Foreword	v
	Preface	vi
I	St. Nicholas Abbey	1
II	Slave Huts, Stone Huts and Chattel Houses	6
III	Sunbury Plantation House	15
IV	St. Ann's Garrison	19
V	Plantation Houses	25
VI	Historic Bridgetown	35
VII	Historic Speightstown	44
VIII	Suburban Houses	49
IX	Houses of Leaders	55
X	Houses of Worship	60
XI	Historic Hotels	65
XII	Parliament	69
XIII	Finale Treasures of Barbados – Past, Present and Future	76
	References	82
	Glossary	84
	Index	87

To Maureen and Rob
My Greatest Treasures
with Love

Foreword

by
His Excellency Sir Hugh Springer,
GCMG, GCVO, KA, CBE
Governor-General of Barbados

Treasures of Barbados by Henry Fraser is an act of piety and is in its own category a treasure of Barbados. Let us all read it and do our best, so far as lies in our power, to preserve the heritage he has so lovingly described. It should be placed in the Library of Parliament and in the Public Library. The library of every primary and secondary school should have a copy as well as the libraries of the University of the West Indies and our other tertiary institutions.

Barbados is fortunate to have citizens like Henry Fraser. May the supply never fail.

February 1990

Preface

The invitation in 1988 to create and present a television series on the architectural history of Barbados was almost like an answer to prayer.

The Barbados National Trust, since its inception in 1961, has worked hard for the preservation of buildings of historic and architectural interest, but the decades of the sixties and seventies were periods when progress was seen by most people as synonymous with demolition of the old and building anew. The years 1982 and 1983 saw an awakening, all over the Caribbean, of interest in historic buildings, with the publication of books on these buildings in Barbados, Trinidad and Jamaica[1-4].

In 1985–86 my historian friend Warren Alleyne and I researched, photographed and wrote 53 weekly articles 'Preserving our heritage – historic buildings reborn' for the *Sunday Advocate of Barbados*. These articles were well received, but it seemed clear that only the medium of television could ever carry the important message of 'development through preservation' with the conviction needed to save the important built heritage of Barbados. As Honorary Secretary of the Barbados National Trust I approached CBC-TV in January 1986 with a proposal for a National Trust series of six programmes. The idea was greeted positively, but a generous sponsor would be needed. Extensive efforts failed to secure sponsorship, and the scheme fell through.

So when Sissons Paints, nearly two years later, proposed a full series of 12 or 13 programmes, ranging widely over the architectural history of Barbados, to be researched, written and presented by yours truly, it was obvious that a very generous and enlightened champion of Barbadian heritage was at hand. Even my choice of title was allowed. Inspiration came at the eleventh hour, from that unique 1948 classic on Caribbean architecture *'Treasure in the Caribbean'* by Angus Acworth. And so *Treasures of Barbados* was born.

The challenge of such a task, with an initial four-week preparation time, was sobering. The demands of a weekly script and a weekly production, come rain, come shine, were horrifying. But the cooperation of a highly professional production team, willing to work on Sundays, a supportive wife and son and helpful friends all made it possible, with many a programme completed in the nick of time. The challenge of modifying teaching techniques from the medical classroom, clinic or bedside to the camera and hence a national audience was a great one, but the recipes are not very different: large aliquots of love for the subject, enthusiasm and hard work; and remember to look the audience – patient, pupil or population at large – in the eye!

Barbadians clearly were ready to find out about our built heritage. Questions flowed and the impact has been seen in the restoring and repainting of many an old house, both as homes and business places. Two videos of *Treasures of Barbados* have been produced, in response to demand, of the first twelve episodes (six episodes on each tape). Two further episodes were created to commemorate the triquintennial of Parliament, aired on 25 June and 2 July 1989. This book includes a version of those episodes as chapter XII, with the initial episode 12, Finale, now chapter XIII, concluding the book. The entire scripts have had to be significantly edited, to improve the impact of the rather informal spoken word or idiom when it appears on the printed page. It was also possible to add many useful explanations or facts, especially dates, that would have been inappropriate for the television screen.

References have been kept to a minimum, since the book is 'popular' in its aim, rather than 'academic'. Therefore primary sources have only occasionally been given, preference being for more comprehensive secondary sources that would be more easily available to the average reader. The goal has always been to keep it simple but interesting, and to give as many examples as possible. Much more detailed information can be found on some subjects in the references, but a particularly useful book will be *A–Z of Barbadian Heritage*, recently published by Heinemann Publishers (Caribbean) Ltd., which references many more primary sources.

I would like to acknowledge the enthusiasm and cooperation of Director/Producer Betty Lynch of CBC-TV, and of indefatigable photographer/cameraman Richard Barnett in the production of

the television series; and of all other CBC-TV management and staff who helped in various ways at other times. I am most grateful to John Oxley of Smith and Oxley and to Sissons Paints for providing the challenge and making it possible; to Warren Alleyne and Ronnie Hughes for providing valuable information, help and comments at short notice; to Tony Phillips and Warren Alleyne for help with both the TV script and illustrations for Parliament; to John Gilmore and others for the loan of pictures, and to Lennox Honeychurch and others for the use of visual materials in the programmes; to Lieutenant-Colonel Stephen Cave, Nick and Sally Thomas, John Bell, Rose King, the Director of the Barbados Museum, the Barbados Defence Force, Ombudsman Sir Frank Blackman, the Clerk of Parliament, the Speaker of the House of Assembly, and many, many others for their cooperation in giving access to properties or grounds and helping me in many ways; to Bill Lennox of Macmillan Caribbean for his interest and encouragement in this publication; to my friends Felix Kerr and Willie Alleyne for sharing their enormous photographic skills and their slides; to Enid Carter, Marcia Murrell and Grace Ifill for translating illegible manuscripts into legible typescripts; to the many people out there whose encouragement kept me going; and most of all to my wife Maureen and son Rob, who supported, encouraged, critiqued, laughed at the jokes and sacrificed precious family Sundays for four months.

Chapter I

St. Nicholas Abbey

Old houses have an immense fascination for most people. It has been said that 'the story of houses is the story of the people who build them', yet behind the bricks and mortar are not just stories but the secrets of centuries – the hopes, the lives and tragedies of other generations, that often we can only guess at. St. Nicholas Abbey is one of the most fascinating, mysterious and romantic of the historic houses in Barbados, and indeed, of this entire 'New World', re-discovered by Christopher Columbus almost 500 years ago.

When Barbados was settled in 1627, it was almost certainly covered with dense forest, like that of Turner's Hall Wood, the last major surviving patch of largely unaltered tropical rain forest in the island. In fact, Turner's Hall Wood is the only true pre-settlement vegetation left in Barbados. These forests had to be cleared to plant crops and the timber was used to build the simple wooden houses and churches of the early settlers.

The earliest buildings were crude buildings of wood, mud and thatch. As the historian Richard Ligon said in his book of 1657, 'The planters never consider which way they build their houses, so long as they get them up'.[1] Yet about ten years later, just 30 or so years after the settlement, this gem of a house was built in the hills of St. Peter.

Nicholas plantation was the property of Benjamin Berringer and John Yeamans, who were both planters and apparently partners in real estate speculation. Berringer was married to Margaret Foster, a clergyman's daughter, but he spent the

St. Nicholas Abbey – East façade with curvilinear Dutch gables. A typical Jacobean design 'modernised' two centuries ago with a Georgian portico.
(Henry Fraser)

years 1652–56 in England, leaving his wife and daughter at home. He returned in 1656 and St. Nicholas Abbey was almost certainly built between then and his death in 1661 – perhaps an attempt to make up to his wife for his long absence!

The legend goes that Berringer was killed by Yeamans in a duel, but recent research by Peter Campbell[2], editor of the *Journal of the Barbados Museum and Historical Society*, has established that Berringer died in suspicious circumstances at a house in Speightstown in 1661, almost certainly of poisoning. And Governor Lord Willougby wrote that Yeamans procured Berringer's death 'for no other reason but that he had a mind to the other man's wife'. Yeamans did indeed marry Berringer's wife, and lived at Nicholas. But he was also a power-hungry, political opportunist of the first order; he changed from Royalist to Cromwellian and back to Royalist, receiving a Knighthood from Charles II after the Restoration. He became leader of a group called the Barbadian Adventurers, who explored the Carolinas, and he went on to become Governor of Carolina[3]. He was certainly the 'J.R.' (of the American TV soap opera 'Dallas' fame) of the seventeenth century!

St. Nicholas Abbey is a 'Jacobean house', a term used to describe houses built in Britain between the reigns of James I and Charles II, in the early and mid-seventeenth century. It is said that only three such houses survive in the entire Western Hemisphere – one is Bacon's Castle in Virginia, and the other two are both in Barbados, St. Nicholas Abbey and Drax Hall, both older than Bacon's Castle – facts which make Barbados of considerable importance as the site of such early English colonial buildings.[4]

What most distinguishes St. Nicholas Abbey is the roofline: the elegant curvilinear gables at the front and sides, the tall, ornate brick chimneys and the decorative finials (the simple but graceful sculptures along the roof, on the apices and in the valleys between the gables); also the very tall, dignified shape of the house and the rich pattern of plaster quoins around the windows and at the corners of the building. Many of these features were borrowed from Dutch architecture, especially the gables, which are actually known as Dutch gables. The only other original Dutch gable in Barbados is that of the seventeenth century Nicholls building on the corner of Lucas and James Streets in Bridgetown (now called Harford Chambers). In those days, Anglo-Dutch trade was very strong, and the British, like so many West Indian islanders today, loved to borrow from the more fashionable Continentals; like us, they too were followers of fashion, and this Jacobean mansion would have been considered the height of fashion in the 1650s. Berringer probably bought the plan in England in 1656, brought it back, and had it built exactly as in the plans, with chimneys, fireplaces and all. There are still fireplaces in two of the bedrooms – a source of surprise and delight to today's visitors.

There are other unique features of St. Nicholas, almost certainly dating back to the original design. There is, for example, a massive Dutch kitchen chimney breast; this dramatic structure is certainly the biggest and most impressive kitchen chimney in the island. (Compare the fine chimneys and fireplaces at Oughterson, Clifton Hall and Eastmont.) Originally the Nicholas kitchen was a separate structure to reduce fire hazards, but it was later joined to the main house.

To the south of the house is the well-preserved design of a medieval herb garden. It was both fashionable and good sense in those days to devote special attention to the growing of herbs, particularly medicinal herbs. Within this traditional, walled garden is an intricate design of tiny beds, perfectly preserved for 300 years, but without the medicinal herbs. Such needs are best filled today from a modern pharmacy!

Beyond the herb garden is a walled courtyard, with another unique architectural feature. On the left is a pair of matching outhouses – the bath and the toilet or privy. They are roofed with original clay tiles and are well-preserved. Until the 1930s, the original four-seater toilet arrangements were still intact: three standard or adult size, and a smaller one for children, around a large horseshoe-shaped seat, for communal use by the whole family at once if need be – an example of the earthy intimacy of the seventeenth century! Sadly the seating is no longer there, nor the scavenging land-turtles which performed useful house-cleaning duties in the gully beneath the privy! These charming conveniences were replaced in the last century by a small indoor bathroom with a copper tank overhead, to which water was pumped by a Victorian hand-pump, and later still by a more modern, early twentieth century bathroom wing, the major modernisation to the house.

The only other significant changes to the exterior are the Georgian arcaded portico and the Georgian sash-windows. Nicholas was acquired by

Sir John Gay Alleyne, Speaker of the House of Assembly for 30 years, through his wife Christian Dottin in 1746. Now just as Jacobean gables and tall chimneys were high fashion in the 1650s, Georgian arches were all the rage by the eighteenth century, and it seems almost certain that this portico was Sir John's attempt to update and improve what by 1746 may have seemed a very dated and dull old house. The triple arcade was a typical Georgian entrance, and we can see it again and again at

Kitchen wing with massive Dutch chimney breast.
(Henry Fraser)

Courtyard bath and toilet outhouses.
(Henry Fraser)

Solidarity House, Cleland, Porters and many other surviving plantation great houses. The sash-windows were also the height of fashion, replacing the casement-windows of the previous century. Glass by this time was cheap and Georgian houses were being built with these large panes of glass invariably arranged in two sets of six. And over the portico was a large 'French door' giving access to the roof of the porch.

It is thought that the ornate Chinese Chippendale staircase also dates from this period, that is 1746, as this type of design was then very fashionable; it is unique in the Caribbean, but there is an almost identical staircase in the late eighteenth century Palladian mansion, Lower Brandon, on the James River in Virginia, not far from Bacon's Castle.

The interior mouldings and other decoration may have been original or part of Sir John Gay Alleyne's improvements. Intricately carved mould-

Chinese Chippendale staircase and eighteenth century grandfather clock.
(Felix Kerr)

The cedar panelled dining room.
(Felix Kerr)

ings enhance the cornices, the main beams and the arched doorways, over which lions' heads are placed. The cedar panelling of the front rooms, however, is much later (1898) during the time of the grandfather of Lieutenant-Colonel Stephen Cave, the present owner.

The contents of the house are as fascinating as the house itself. Pride of place must go to the magnificent grandfather clock, standing on the first stair landing for 200 years, from the time of Sir John Gay Alleyne. But the main living rooms are full of interesting things, particularly the many chairs – a 1720 veneer-on-softwood chair on loan from the Barbados Museum, an elegant ball and claw sofa of mahogany, and a set of unusual caned Regency period chairs from Farley Hill. My favourite is the superb Victorian reading chair, actually made in 1934 in London from an 1880 design. It has adjustable head- and foot-rests, a movable reading light, book stand and drink tray. All it needs is someone to pour the drink! What a lot of reading one could do in a chair like this!

Around the study or library is a magnificent collection of Wedgewood portrait medallions, also on loan from the Barbados Museum. But perhaps the most interesting piece of furniture of all is the superb bed of Marie-Louise, Empress of France. She was an Austrian Princess who became the second wife of Napoleon Bonaparte when he divorced the Empress Josephine who could not give him a son. Marie-Louise's son became Napoleon the Second but he never reigned and died aged 21. After Napoleon's abdication in 1814 Marie-Louise returned to Austria, was made the Duchess of Parma, and lived a life of voluptuous splendour in such exotic places as Majorca. The bed is Spanish and must have been made in Majorca or in Spain, and we can see the richly ornamented headboard with its large letter M, and the coronet of the Empress. Marie-Louise was a charming beauty; her fame spread throughout Europe for what we might call her generous nature and liberal virtues. What tales this bed could tell if it could only talk!

St. Nicholas Abbey is a living museum. Every corner yields some exciting find – the Spanish jars, the fireplaces, the drip-stones, the Victorian water-pump and the huge pineapple finials on the corners of the garden wall; the old coach-house and stable, where a 1930 film of plantation life, taken by Colonel Cave's father, is shown; the boiling house with the sugar plant from Fairfield Plantation in St. Michael acquired for St. Nicholas by The Barbados National Trust; the sugar windmill and the smaller water-mill; its own luxuriant forest of giant mahogany trees and majestic cabbage-palms behind the house; and, of course, the magnificent avenue of mahogany trees that leads from St. Nicholas up the famous Cherry Tree Hill to the spectacular Scotland District and Morgan Lewis Mill beyond.

Three hundred and thirty years of history are enshrined in St. Nicholas Abbey, and every year thousands of visitors make the pilgrimage to see one of the most important architectural relics of the Western Hemisphere – truly a *Treasure of Barbados*.

Giant pineapple finial on the garden wall – the traditional symbol of 'Southern hospitality'. *(Henry Fraser)*

Chapter II

Slave Huts, Stone Huts and Chattel Houses

Barbados is famous for its great houses like St. Nicholas Abbey, Sunbury and Villa Nova. But it has an equally rich heritage of small houses, from the humble slave hut to the unique chattel house.

The earliest house forms in Barbados would have been built of timber or wattle and daub – that is freshly cut logs and branches, plastered over with mud and roofed with thatch of palm leaves or long grass or (later) trash from the sugar cane. Such houses survive in Martinique and in the hillside Tapia house of Trinidad. A nineteenth century photograph of one of the last in Barbados can be seen in the book *Barbados, Yesterday and Today*[1].

But those huts were essentially perishable. In Barbados, coral stone could be quarried all over the island. It was therefore easily the most available and long-lasting building material around after the forests were replaced by cane fields. It was ideal for building cheap, strong, hurricane-resistant huts with very thick walls. And the low hip-roof, sloping on all four sides, covered now with galvanised iron (corrugated zinc-coated iron sheets) but originally with thatch, is the same on most of the surviving huts.

Most of the **slave huts** have been destroyed, but at Moore's Hill in St. Peter, on the tenantry lands of Nicholas Plantation, is one of the best examples. It is a fine specimen and is exactly like the four which were occupied until recently at Alleynedale village nearby. Unfortunately, all four were destroyed in 1987 when the architects of the Belleplaine to Chequer Hall (the site of the Arawak Cement Plant) highway decided they should go, and the road was carved right through the middle of the village.

Closer to Bridgetown is the house known as the Leacock slave hut, in a secluded village near the bottom of University Drive. This has a similar stone structure but a gabled roof and partly-timbered gable ends.

There are many other **stone huts** up north in St. Lucy. In the low limestone hills of Graveyard and Cave Hill, Hannah's Village and the Risk, are many little stone huts just like the slave huts, although some have been modernized with glass-windows. But are they slave huts? Some of the Graveyard people say so, but no one is really sure. One theory, since they are isolated, spread over barren hills and generally some distance from major plantations, is that they may have been the huts of the indentured servants or 'red-legs' who were given these infertile lands or the lands 'below

7 Slave Huts, Stone Huts and Chattel Houses

Slave hut at Moore's Hill, part of the original tenantry lands of St. Nicholas Abbey.
(Henry Fraser)

Two slave huts at Alleynedale village, demolished in 1987.
(Willie Alleyne)

the cliff' in St. John, after their seven years of bonded hard labour[2]. The old stone walls surrounding many of them make them look just like the peasants' crofts of Scotland and Ireland, which would have been their homes before they were 'Barbadosed' (this is the old-time word for being sent to Barbados as a sheep stealer, a debtor or a political prisoner – for in those days, if you stole a sheep or a fowl or simply said the wrong thing, you were sent to toil in the sun for seven years).

After emancipation, almost every freed slave was effectively tied to his plantation, from which he rented land, known as tenantry land, to live on. It is not clear exactly when the movable or chattel-house came into vogue but it may have been accelerated by American developments – good cheap pine-boards became available and by the late nineteenth century, when photography records the scene for us, standard wooden frame chattel houses, sometimes with walls of shingles, were the norm in every village.

The **chattel house** is essentially modular in concept – units are rectangular as in the beautifully painted (red and white), basic house design standing prominently on Upper Tweedside Road next to Hinds Furniture: they are invariably twice as

A prominent, beautifully preserved house at Westmoreland, St. James.
(Felix Kerr)

One of the last of the shingled chattel houses. Note the wider rear unit and the shed roof, and the traditional lace curtain at the front window.
(Felix Kerr)

An elegant 'upstairs' chattel at Green Hill, St. Michael.
(Felix Kerr)

9 Slave Huts, Stone Huts and Chattel Houses

long as wide, usually 8 × 16, 9 × 18 or 10 × 20 feet. There is always a central door on the long side, facing the street, with a window on either side. Perfect symmetry was the key to house design, and one has to look hard to find a traditional chattel house without it. The roof is a gable (two slopes) or a hip-roof (with four slopes).

The term chattel house is an archaic or old-fashioned term. By definition a chattel is movable, like the rest of a man's 'goods and chattels', a common phrase in the King James version of the Bible. Changing your job meant moving your house, on a mule cart in the old days, on a truck today; and every house can be stacked up section by section and moved in a few hours, usually on a Sunday.

A house grows by the addition of new units, one behind the other like a stack of cards. Usually the unit or house behind the 'front house' is wider, to allow front ventilation and a central corridor. Finally, traditionally, the last unit has a flat roof and was known as the 'shed roof'. Occasionally, the house grew to a much greater size with the addition of a two-storey portion at the rear.

Just as the house grows with a larger family or a higher income, the detailing and decoration may get better and better. Window hoods are added, either with jalousies or solid, bell-shaped hoods, kown as bell pelmets. There are decorated fretwork barge-boards at the gable ends. Best of all is the beautiful pedimented porch, Palladian inspired with turned wooden columns, architrave and pediment, but with Victorian style fretwork! The porch is a very English thing, and although it is obviously of universal value in protecting you from a downpour

A well crafted house with a pedimented porch, delicate fretwork and 'bell pelmet' window hoods (Pilgrim Place, Christ Church). The wooden trim or 'barge boards' at the gable ends were often richly carved.
(*Felix Kerr*)

when you reach home, it is rarely seen in the folk architecture of the other islands.

There is a much admired chattel house at Lower Carlton in St. James which is one of the best preserved and finest decorated of all our chattel houses, with a truly elegant porch. But porches have been largely replaced today by open verandahs with wooden posts.

A house could be greatly enlarged, at little cost, by adding a verandah. In Speightstown, for example, is one of many small houses with a lavish verandah and a well-defined space or front patio created by handsome high walls. Such a house can look very grand, and with a walled extension at the back, overcomes the small size of the original unit. Note the usual detailing of the front wall. The elegant carved recessed panels first appeared in Barbados at Sam Lord's Castle, built around 1820, and they have become a tradition in Barbadian stonework ever since.

Other, larger houses have ornate verandahs closed with jalousies and with parapets to protect the roof. Houses of this size would invariably be fully decorated, with smart pelmets, tin or wooden tracery, ornate barge-boards and mouldings, and were but a tiny step away from the prototype

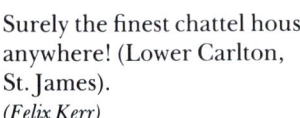
Surely the finest chattel house anywhere! (Lower Carlton, St. James).
(Felix Kerr)

A spacious verandah helps to cool a house converted to a west coast shop.
(Henry Fraser)

11 Slave Huts, Stone Huts and Chattel Houses

An ornate stone verandah converts a tiny house into a suburban villa (Maxwells).
(Felix Kerr)

A classic jalousied 'front gallery' with decorated parapet, at Welches plantation in St. Thomas. Note the calabash tree.
(Henry Fraser)

A derelict at Fitz Village, St. James, with delicate portico and front wall.
(Felix Kerr)

Shingles on a more permanent stone base. Note the elegant glazing of the front door.
(Felix Kerr)

One of many chattel houses which is now a trendy boutique (Paynes Bay, St. James).
(Henry Fraser)

suburban house; only a stone front wall and a wider frontage distinguish wooden suburban house from wooden chattel house. All the features of the modular chattel house – with its many sections and many gables – are repeated in the wooden suburban house which might be called 'a chattel house of stone', similar in everything except the fundamental concept – mobility!

The chattel house is said to be disappearing; as our aspirations take us from Bank Hall to Barclay's Terrace, from Eagle Hall to Ealing Park, the wooden house is left behind, and the artists and tourists bemoan their loss, because they slowly decay, overgrown with vines and left to become unsightly nuisances. Or they are swallowed up by shopping centres or cannibalised by concrete blocks which appear, like a sheep in the night, and engulf them!

Certainly they are familiar, attractive and practical for a small family or couple; they are cooler with their high gables and jalousies than their flat-roofed concrete successors, whether of wood or concrete. But are they viable, or will they all be gone, like the slave huts, in another ten years, replaced by the new style wooden houses with flat roofs and corner verandahs? Will they only survive in the paintings of Fielding Babb and Clairmonte Mapp, of Jill Walker and Virgil Broodhagen?

Well, not every Barbadian thinks so. There is a new life for many chattels, as new pride is displayed in what may be the most distinctively Barbadian aspect of our heritage – a unique house form that has attracted worldwide attention in architectural circles. Like many old houses in tourist districts, some chattels are now thriving boutiques, or shops of all kinds. New style houses are hankering more and more after traditional decoration, and more and more old houses are being proudly rehabilitated.

Folk architecture is the architecture of the people. It is born of necessity, in simple but practical forms, evolving to suit the climate, the materials and the social influences (in our case, regard for the ubiquitous Georgian architecture of the larger buildings and the insecurity of the tenantry system). The Barbadian personality has imprinted itself on these unique, delicately crafted, ingeniously designed, mobile houses. But not only did these houses evolve to a sophisticated level of their own; they

Pride of Barbados: a cock struts past a brilliantly painted modern version of the chattel house.
(Felix Kerr)

re-informed the architecture of the more wealthy, for in the old Barbadian suburbs of Belleville or Black Rock are simply larger versions, in wood or stone, of the same house form. We see in some of these suburban houses the synthesis of the tastes of the craftsman and his employer in a traditional or vernacular architectural language that evolved over the last 200 years.

And so it seems, that like black pudding and souse or coconut bread, Cropover, cricket and other products of our Bajan heritage, the chattel houses will not be discarded, but will stay with us – enlarged, modified, restored or re-used, in different roles – valued highly as some of the very finest *Treasures of Barbados*.

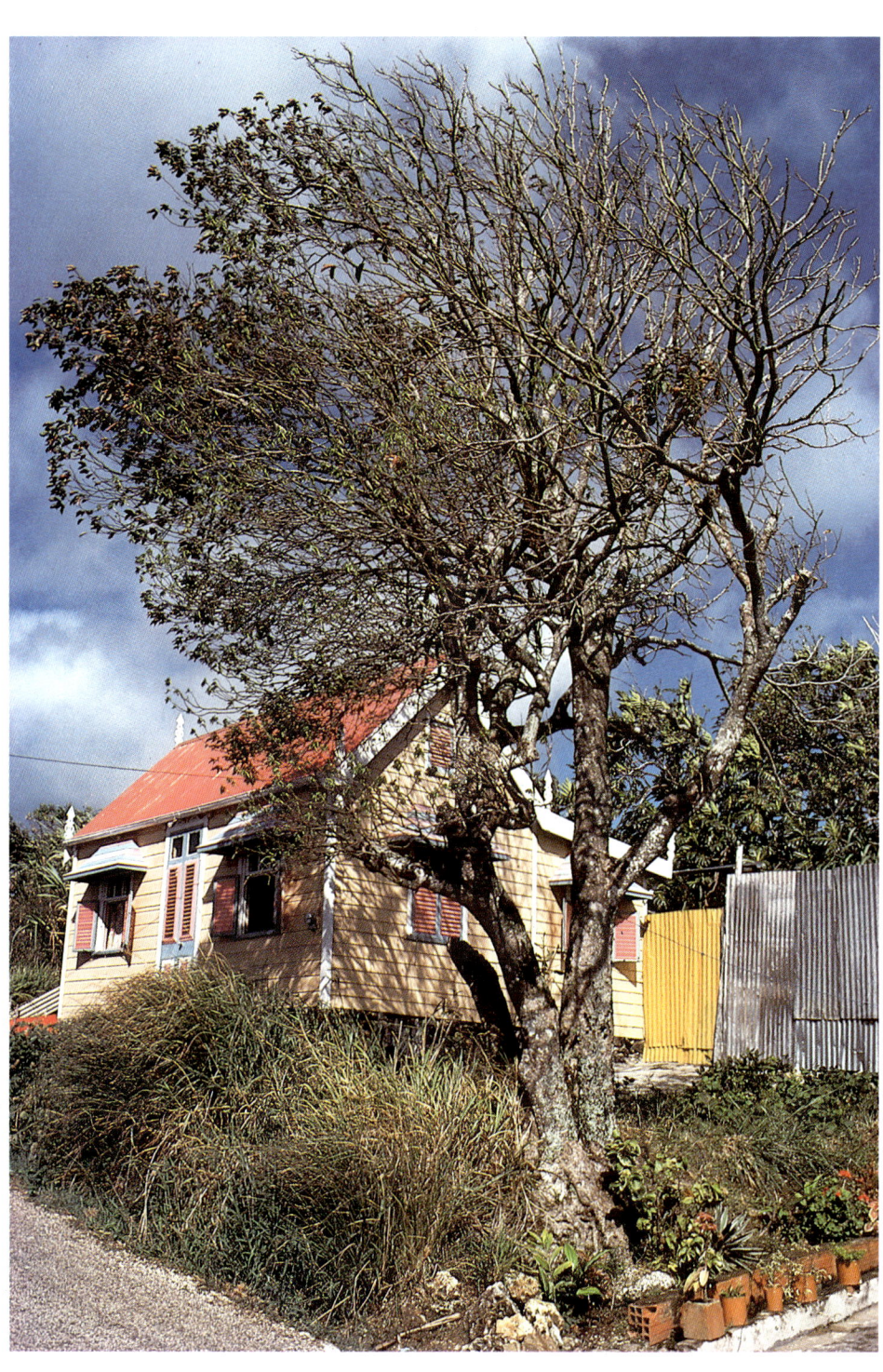

Simple but eloquent – a Barbadian icon.
(Felix Kerr)

Chapter III

Sunbury Plantation House

The south front, with traditional breadcart in the foreground.
(Felix Kerr)

Treasures of Barbados began with the remarkable Jacobean mansion St. Nicholas Abbey, built well over 300 years ago. In the second chapter we traced the history of folk architecture, from the slave hut at Moore's Hill, on Nicholas plantation, to the most elegant chattel houses, the most distinctively Bajan creations among our cultural icons. In this third chapter, we look not just at an architectural treasure but at much more of the Barbadian culture, through 300 years of building, craft, artefacts and social customs – a panorama of Barbadian heritage[1].

Sunbury Plantation House in St. Philip is a classic Bajan plantation great house. It is built like a fortress, to protect it from hurricanes, with walls two feet thick. It is essentially a rather plain house of two storeys built over deep cellars, with plaster quoins at the corners and a double hip-roof. The present porch and front steps replaced the original smaller porch (shown in a Victorian water-colour) in 1935. It is a typical 1930s Barbadian verandah, decorated with the Bajan mason's favourite motif – the recessed panel, first introduced at Sam Lord's Castle in 1820, and employed in decorating walls and houses of every size and status ever since.

No one is sure exactly when Sunbury House was built. The plantation was clearly marked as Chapmans on the Ford Map of 1681, when it was owned by Mathew Chapman, and is shown with its own mill. But did he build the house?

Its style could fit anywhere between that of St. Nicholas in 1660 and the great hurricane of 1780. We know it survived the 1780 hurricane because of a written account that it lost its roof then. The huge gutter head on the West side seems to confirm that. It is inscribed B for Barrow, the owner at the time and a member of Council, with the letters IHS standing for 'In His Service' (meaning 'In God's Service') and the date July 1788. It receives rain water from the post-hurricane 'fish pond' roof – this was a copper tank in the valley between the front and back roofs. It was common 200 years ago but only half a dozen are known to survive today. The rain water was led into a large iron tank for domestic use. (Some of the well preserved fish pond roofs are at The Eyrie, Villa Franca, Westgate on Barbarees Hill, Enfield House on the corner of River Road and Jemmott's Lane, and Stepney House.)

Around the corner from this ingenious water supply was the traditional long kitchen wing, with the fireplace and chimney at the end, far away

from the house. This area is now a courtyard restaurant and bar.

Since the first recorded 'great' hurricane to devastate Barbados was on 31 August 1675, the house was probably built or rebuilt some time after that or in the early 1700s, with great emphasis on strength. The windows are typical eighteenth century Georgian sash-windows with a variety of shutters – long American colonial, typical Bajan half-shutters with jalousies to keep rain out but let air in, and half-Demerara window hoods with fixed sides but a movable or 'push-out' central panel. The doors too have sturdy hurricane shutters which fold back against the door jams and are panelled in traditional style. They can be rapidly closed and barred to fortify the house against the likes of Hurricane Gilbert, which devastated Jamaica and Mexico in September 1988, or Hurricane Hugo which narrowly missed Barbados but flattened Montserrat on 17 September 1989.

Sunbury is a busy, lived-in family house, but it contains just about every artefact or variety of furniture from Barbadian history. When the last owners, the two Cameron sisters, died in their 80s in 1981, Sunbury was an impressive relic of nineteenth century life largely unaltered for nearly a hundred years, and filled with a treasure trove of antiques. In the huge drawing room, now, are two very old Barbadian mahogany couches, a single-ended and a double-ended version. This kind of couch or sofa became totally Bajan in design with rich, energetic carving and caned backs and arms. Almost every Bajan house had at least one, from Sunbury to the smallest chattel in the village.

In the planter's office is a classic planter's desk, with its ranks of 'pigeons holes', not for keeping pigeons but for all those bits and pieces, odds and ends that wives hate to see lying around the house. Next to it is a typical old-time accounts book or ledger from 80 years ago, with every purchase from animal feed to nuts and bolts.

There are a pair of Berbice chairs, named for that part of Guyana where they originated. They are an elegant reminder of the close blood links between many Bajans and Guyanese, perhaps the closest members of our West Indian family. Most old-time Bajans know these chairs simply as 'long chairs', for relaxing after dinner and going to sleep in. There is a male chair and a female chair; the lady's had lower foot-rests, for more discreet and ladylike elevation of the legs!

On one wall are the portraits of past Governors and Governors-General, from Sir George Ayscue in 1652 to Sir Deighton Ward in 1989. Sir John Pope-Hennessy is remembered as the Governor who provoked the Confederation riots with Britain's plans to federate Barbados and the Windward Islands as a Crown Colony in 1876. Sir Mark Young was Governor during the 1937 disturbances.

The huge Sunbury dining table of Barbados mahogany has spent its lifetime here. On the

The magnificent drawing room at Sunbury.
(Nick Thomas)

sideboard are Sam Lord's delicate red-patterned claret glasses and decanter.

The staircase is thought to be turn-of-the-century, made from a mahogany grown at Sunbury. It is grand in conception but a little clumsy, almost rustic in some of the detailing. The hanging key-basket in the stairwell is a fascinating relic; it holds the pantry keys and would have been let down on a string in the morning by the lady of the house for the housekeeper or chief housemaid to unlock the pantry cupboards.

Upstairs we find four-posters and all the paraphernalia of genteel survival 100 years ago. A mosquito net hangs over a very old stump-bed almost as broad as the famous Bed of Ware in the Victoria and Albert Museum, reputed to sleep fifteen! We can see a number of old kerosene lamps, the ewer and basin for washing 'the bare essentials', and a pair of ancient fly-catchers – honey or syrup was placed in the glass moat and no greedy fly could hope to escape!

In the North-East bedroom is another four-poster, this one from Bulkeley House in St. George, laid out with all the accoutrements of a Victorian lady's wardrobe – the arm-length gloves, the calf-length knickers and full-length underwear – a far cry from today's sleek pantyhose and body stockings! And what a delicate lady's parasol – now back in fashion with today's Bajan ladies on a scorching hot, sunny day! There is a Victorian sewing machine for darning all these underwear, and the latest design in adjustable standing lamps – a kerosene lamp. In the window alcove is what looks like a comfortable armchair but the cane seat can be raised to reveal an old-time commode.

Next door is the nursery with a small iron four-poster, a porcelain foot-warmer, baby bottles, a baby bath and a toy dinner service. There is an early nineteenth century washstand with two exciting innovations of the last century, a tap and a plughole for water to run out into a bucket below. But the domestic servants still had the chore of fetching clean water upstairs and dirty water down.

In the cavernous cellars and on the lawns of Sunbury is Keith and Angela Melville's fascinating collection of horsedrawn vehicles and plantation artefacts which is unique in the Caribbean, and perhaps the entire Americas. There are, for example, two carriages on loan from Johnson's Stables as Johnson's have changed them for something a little faster and more fashionable! These are an 1830 buggy and a four-wheel phaeton named after Phaethon, son of the Greek Sun-God who drove a spectacular chariot. In the same room are some of the sugar plantation's working carts such as the ox-drawn Dray Cart, the Mule Cart and the Donkey Cart. A few donkeys and donkey carts still do yeoman service at children's parties, but the donkeys are fast dying out. (The National Cultural Foundation maintains a register of donkey cart owners and a decorated cart parade is a feature of the annual Cropover Festival every July.)

In another room is a wheel of enormous significance, perhaps the first major Bajan sugar industry invention exported to the outside world. This is one of the famous iron wheels designed and forged by Miller Austin, grandfather of former Prime Minister Bernard St. John (1985–86). Miller Austin was a self-made man with many skills, making his name as an inventive blacksmith, and becoming the first black man to buy plantations in St. John (Malvern and Eastmont), nearly 100 years ago – surely a great example of a small businessman developing a local craft to a highly successful level.

The yam cellar is packed with tools and artefacts of interest; for example a home-made device known as a 'horse drencher' with the appropriate straps and a funnel for pouring medicine down the horse's throat. In one corner is a set of old Mr. Cameron's historic golf clubs from Scotland, where the game was invented, brought to Barbados nearly 100 years ago.

Another room has been virtually turned into a museum of cooking in Barbados exhibiting a wide range of implements, from the humble coal pot, this one of clay, to the elegant cast-iron wood-burning stove. Of course, coal pots are prized items once again, with the current rage of roast-corn vendors on every corner, from Baxter's Road to Banks Brewery. There is an unusual stove, where a flat iron was heated in coals and placed with tongs in an insulated hole under the pot. Then came gas and kerosene. You can see ice boxes from the nineteenth century, to hold ice from Nova Scotia; mortars and pestles of every size, carved from local woods; monkey jars, and kitchen tools of every kind, made by the local potter, carpenter, tin smith and weaver. So we can reconstruct many aspects of domestic life in the 'olden days'.

Today we take clean water for granted, but consider the ingenuity of the Bajans in devising a method for purifying water. Dripstones were carved of coral stone (there used to be a thriving

trade in dripstones as they were exported to neighbouring islands); water was poured in at the top and dripped through not one but two of these porous stone pots or 'purifiers' (dripstones) into an impervious marble bowl below. It would then be dipped out, probably with a calabash gourd, and poured into jars which were called monkey jars or 'monkeys'. These are the traditional Chalky Mount clay water-jars (made by traditional potters from local clay, at Chalky Mount in St. Andrew). They keep water cool by evaporation of moisture from the clay surface, which is left unglazed: this works best if the 'monkey' is kept in the breeze on a window-sill, hence the term 'cooler-window', for a window with a ledge, shaded by a long Demerara window-shutter or hood.

There were many delightful variations of the little 'houses' for dripstones, such as the Gothic style at Codrington College, but the large stone pots were standard and they were most often placed in an archway under stairs. There is a fine arched brick structure at the Barbados Museum, with a complete set of stones, and a fine stone one at Francia Plantation House in St. George, recently opened to visitors. The largest of all must be the enormous example at Fisherpond plantation. That at Malvern is in the shape of a small sugar windmill, while at Chelsea House is an unusual dripstone house of brick.

The ingenuity of Bajan craft and entrepreneurship is seen in every corner of Sunbury. Look, for example at the bread cart, a sentinel in every village in the old days. It was a mobile bread shop. It was filled up in Roebuck Street or wherever the 'bread man' got or baked his bread, and pushed by each bread man through *his* district; full of sweet-smelling choice bread, penny breads, turnovers and cassava pone. Can't you just imagine and almost smell those coconut turnovers that would have filled these old carts in the days when the bread man's arrival was the event of the day for the children?

And then there is the Melville collection of old photos, recording everything from 'red leg' or poor white fishermen to our famous railway of 1882 to 1937. Finally, also in the basement and worth a chapter of its own, is the optical museum of the late Harcourt Carter, grandfather of Keith Melville and father of Optometry in Barbados.

Sunbury is both an old house and a modern home, lived in and opened to visitors by Nick and Sally Thomas; both a panorama of culture and crafts and a living plantation museum, where, if you are lucky, you will even see the horses being shod in the yard some mornings. It is surrounded by mahogany woods and extensive lawns, which are literally covered with the history of agriculture. It is a place for Cropover plantation feasts or for a quiet exploration of the past – it is truly a *Treasure of Barbados*.

The dripstones at Fisherpond plantation in St. Thomas – without doubt the largest and finest in the island.
(Felix Kerr)

Chapter IV

St. Ann's Garrison

The Main Guard, until recently the Savannah Club. The elegant cast-iron work is a Victorian addition.
(Henry Fraser)

To many Bajans, the Garrison simply means the race-track and the Savannah where we go for horse racing, kite flying or jogging! But a Garrison means both a supply of soldiers and a fortified place, and that is just what our Garrison was, although the fortifications were never completed.

St. Ann's Garrison was the headquarters for the British Forces in the West Indies and, strategically, a very important place. By 1824 it was more or less complete, with its impressive Main Guard and its elegant clock tower, the Drill Hall, and barracks for nearly 2000 men. But very few people realize that behind the Drill Hall is a real fortress, St. Ann's Fort, originally known as St. Ann's Castle[1].

The late seventeenth century was a turbulent time in the West Indies. The big powers (especially the Dutch and the French) were fighting all out for gold and new conquests. Barbados was protected from its enemies by high sea cliffs, the turbulent Atlantic and major coral reefs, except for Carlisle Bay and parts of the West Coast, which therefore needed heavy fortification. **Charles Fort**, on Needham's Point, was the biggest sea fort and the main defence for Carlisle Bay. (It is now part of the Hilton Hotel grounds.) But in case the defence system of the smaller forts should fail, in 1696 an enormous citadel was proposed for a site just about where Kensington in Fontabelle is now, to cost £100,000. But the plan was rejected as too costly! Instead, in 1705, **St. Ann's Fort** was begun on the hill just inland from Charles Fort, and above what was then mosquito-infested swamps.

Attackers who made a landing behind Charles Fort, if they survived the mosquitoes, would have first met a high wall, 20 feet above the beach, then a ditch, and then the second higher wall of the keep or castle itself. At the entrance to the keep is the huge powder and ammunitions magazine. Not quite Brimstone Hill, because the idea of a fortified citadel, extending along the cliff top to Bush Hill and Bush Hill House, (residence of the Royal Engineer and the house where George Washington stayed on his seven-week visit here in 1751), was never completed. But as it is, unseen and unknown to most of us, the keep itself is over an acre in size. The tower looks important, but was probably just a 'shot tower', for making shot, and certainly a place for a flag and possibly a lookout.

After the British Garrison was established here in 1780, land was bought up in earnest, and in the next 40 years everything was built except for the

extension to the prison, now the Barbados Museum, which was completed in 1853. Closest to the Fort, within the intended citadel and close to the keep, are the **Stone Barracks**, the prominent cream-painted building well seen from the road on driving up the Garrison Hill. It is the largest and most impressive of the barrack buildings, with its magnificent double tier of roman arches. Just below (in the Bajan sense, that is, to the West), were the **West India Barracks**, all occupied now by the Barbados Defence Force. Nearby are the unique **Iron Barracks**, for a long time in a poor state of repair.

Around the **Savannah**, the finest military parade ground in the West Indies, were blocks A, B and C, again with superb arcades, pedimented central entrances and at the rear, grand double staircases – Georgian Palladian buildings in spirit – a classical style that the British engineers were to impose throughout the West Indies. (Georgian after the British kings of the eighteenth century, and Palladian after Andreas Palladio, the great Italian Renaissance architect.) It is not surprising that in little Barbados these design elements should have impressed every builder, and be incorporated into the major domestic architecture, as in Parade View, now the Virginian restaurant, at the southern corner of the Garrison[2]. After the great hurricane of 1831 especially, the parapets, arches and double staircases were adopted wholesale in the rebuilding of the planters' houses and the estate buildings.

Some of the finest buildings were for the **General Hospital** at Hastings, now apartments known as **Pavilion Court**, and the **Pavilion**, built for the Medical Officer[2]. This was victim of a serious fire ten years ago and is now a magnificent but tragic ruin. Both buildings are a profusion of Roman arches and cool verandahs.

The **Quartermaster's Store**, later the Garrison Theatre, follows the lines of the West India Barracks, with double verandahs and wooden posts[3]. It has been outstandingly well restored by the Barbados Light and Power Company, at enormous savings over the alternative proposal of new premises, to reveal all of the original arches and the pattern of coral blocks – small blocks of fossilised coral stone laid almost like brickwork. It received a Barbados National Trust Restoration Award and plaque in recognition of the outstanding restoration.

An equally impressive building is the **Barbados Museum**, partly built before 1820 as the prison, and significantly extended in 1853. It is perfectly symmetrical with a large central arch, and two flanking wings. It is built of brick, but is distinctly West Indian in flavour with balconies and jalousies.

The **Government's Welfare Department** on Bay Street was originally the Adjutant-General's

Block B, originally soldiers' barracks, restored for the offices of the Town Planning Department.
(Felix Kerr)

Pavilion Court. The General Hospital for the Garrison, now apartments.
(Henry Fraser)

The Pavilion – formerly the quarters of the Medical Officer, now a tragic ruin, awaiting a fairy godmother.
(Henry Fraser)

The Barbados Light and Power Company – an exemplary 'rehab' job.
(Felix Kerr)

The Barbados Museum – originally the Military Prison.
(Felix Kerr)

Queen's Park House, over 200 years old, one of the finest and least altered classic Georgian buildings. Note the contemporary 'sno-cone' vendor.
(Felix Kerr)

Quarters. It had two fine arches although one has been lost in conversion, and a bow front which may have inspired the Round House nearby. It was recently restored with the help of the Canadian Government. It has served the country well after the departure of the British Garrison, first as the Pellagra Ward of the General Hospital, and then as the Eye Hospital, until the opening of the Queen Elizabeth Hospital in 1964.

Over in Queen's Park is the quite superb **Queen's Park House** or Queen's House[2]. It became the residence of General Vaughan in 1780 but was destroyed by the hurricane of that year and rebuilt in grand style. The property – '14 acres or thereabouts ... together with the mansion ...' – was bought by the Crown in December 1782 from one Edward Falkingham, heir of Henry Falkingham, for 1500 pounds sterling. It is perhaps the model example of creative adaptation of an historic building, because it is now an art gallery and a

theatre. It is a very Georgian building, with perfect proportions and fine detailing, and would make a good case study of pleasing, harmonious, traditional architecture for our speculative builders. The iron balcony was added in Victorian times.

Just behind it is another exquisite building, also called the **Pavilion** (like the ruin of the Medical Officer's Quarters at Hastings) and now part of Harrison's College. Sadly it has been seriously neglected for years and is rapidly following the fate of the Hastings Pavilion and further scorned because its exterior is unkempt!

Gun Hill was the army's hillside retreat away from the mosquito swamps around the Garrison, where half the young men died of yellow fever before they even fired a cannon. There stood the finest of the Signal Stations, linking Bridgetown via Highgate with the Cotton Tower at Bowling Alley Hill in St. Joseph, and Moncrieffe in St. John. From Cotton Tower signals were passed to Grenade Hall (near Farley Hill) and then to Dover Fort, overlooking Speightstown.

Gun Hill is a magnificent site. According to the historian, Sir Robert Schomburgk, in 1848, 'No stranger who visits Barbados should omit to see this spot'[3]. The tower is built like a fortress of brick, with a barrack room and kitchen now surrounded by exotic gardens. Nearby is a larger old barrack, a ruined cookhouse, a sentry box and a magazine, all of these in need of restoration. When a regiment camped up here, tents covered the site to the North. The view from the tower and hill top is spectacular. On the southern slopes of the hill stands a regal stone lion, a huge statue carved from the coral stone of the hillside by Captain Henry Wilkinson in 1868, reputedly inspired by the lion on the box of Lion brand matches.

Cotton Tower, St. Joseph.
(Henry Fraser)

Gun Hill Signal Station, St. George, with the Regimental Band of the Barbados Defence Force in their splendid Zouave uniforms.
(Felix Kerr)

The entire built complex at St. Ann's Garrison is more extensive than Brimstone Hill in St. Kitts, although it lacks Brimstone's spectacular location. It has been described as 'probably the greatest variety of barrack buildings' (in the Caribbean).[4] It is not only an integral part of Bajan life and culture, but one of the most important historic sites in this hemisphere. It has had a seminal influence on the architecture of the historic buildings of Barbados. One might say it put the arches in our architecture, from the plantation great houses of the past to the contemporary epidemic of arches in the present, from West Terrace to Atlantic Shores, and even in many of the verandahs of today's small, wooden pine homes, the modern equivalent of the chattel house.

With the inspired development of our fine Museum, the restoration of Stafford House, (formerly Officers' barracks)[2], the nearby Virginian Restaurant and Seaview Hotel, the Light and Power building, Blocks A and B, the restoration of Brigade House as a medical centre, and finally the recognition of Bush Hill House as the place where George Washington stayed with his brother Lawrence in 1751, the Garrison is at last coming into its own.

The 'piece de resistance', the Main Guard and Clock Tower, is being acquired by Government, and will become the Garrison Centre – hopefully functioning as a tourist Information Centre and Military Museum – part of the proposals of the dedicated Garrison Committee to bring the history of the Garrison alive, and educate us and our visitors about the military history of the Caribbean.

Only the Pavilion and Iron Barracks, and a few smaller structures remain neglected at this time. Key buildings, like loose stones in a crown, they must not be lost. Built in the days of Imperial Conquest yes, but part of the heritage of Barbados, and without doubt, the Garrison brought practical benefits to the country, as today's tourist trade does. And just as the Pyramids of the Imperial Pharaohs are Egypt's major industry, so too is the Garrison of increasing importance to tourism, our main source of income. However one looks at it, it is surely the crown among the *Treasures of Barbados*.

Chapter V

Plantation Houses

Villa Nova, in the beautiful Parish of St. John, is often said to be 'perhaps the finest sugar plantation great house in Barbados'. I am told that it is not nearly as luxurious as some of those being built at Sandy Lane or on the Gold Coast (the West coast or St. James coast) today. Perhaps, but it is indisputably an architectural gem, with its elegant South entrance and cool verandahs, set in a magnificent country garden.

Villa Nova means 'New House'. It was a new house in 1833, when it was rebuilt after the great hurricane of 1831 destroyed the old house. It was the work of the charitable planter, Edmund Haynes, friend of the Moravians and benefactor of Mount Tabor Church nearby, and whose wife taught Sunday School. He built a perfectly beautiful house that was both fashionable and built to last. But let us look first at the development or metamorphosis of the Bajan plantation house in our first 200 years of history, before it reached its apogee in Villa Nova[1].

Early houses would have been crude wooden buildings followed by equally crude stone buildings. Richard Ligon, in his *True and Exact History of the Island of Barbadoes*, describes the planters' houses in 1650 in the most scathing terms[2]: 'the planters never consider which way they build their houses, so long as they get them up; which is the cause that many of them are so insufferably hot'. By that time, of course, sugar was making money, and houses like St. Nicholas Abbey and Drax Hall were soon built, followed by Codrington in St. John, Bromefield in St. Lucy and Warrens in St. Michael[2]. But perhaps only the finest and strongest

Villa Nova, St. John – the south portico.
(Henry Fraser)

Drax Hall, St. George. Jacobean, with a length of copper guttering bearing the date 1653.
(Henry Fraser)

Frenches, St. George.
(Henry Fraser)

The Principal's Lodge, Codrington College, originally the mansion house or great house of Consett Plantation.
(Henry Fraser)

houses of that period would have survived. The rest would have been destroyed in a hurricane, rebuilt because they were old, perhaps termite infested or just out of fashion; or as Ligon said, 'insufferably hot', like some of today's flat-roofed concrete efforts, built with no attention to the prevailing winds or to the well-tried principles of good design for a hot climate.

The Garden, in St. Lucy, is a small plantation where a very old house survives. Its great claim to fame is the fact that Errol Walton Barrow, the late Prime Minister (Premier 1961–66 and Prime Minister 1966–76 and 1986–87) was born here. But it is typical of the very small plantation houses – very low, with walls nearly two feet thick, a hipped roof and a low shady verandah. Inside, the ceiling is raised in what is known as a tray ceiling, because it resembles an inverted Bajan huckster's (hawker's) tray, which is square with sloping sides. This device improved the circulation of air and made the rooms cooler. The house has been extended at the back with an upstairs portion, built or remodeled much later, in board and shingles.

Frenches in St. George, called Spendlove in the seventeenth century, was another small plantation, long since absorbed by a neighbouring estate. But the plantation house remained separate and tells a fascinating story. The little front house remained: again there are small front sections with two hipped roofs, low ceilings and doors, and a quaint little porch. Then came a dozen later additions; it is an 'organic' house, constantly growing, like the chattel house, to fill the needs and aspirations of the occupants as the family grew or as profits improved.

Halton, nearby, just below the hill by Featherbed Lane, has a similar manager's house, growing from what Ligon describes as a *single house* – a long narrow building with but a single roof, and many later sections added. Again the doors of the old section are unbelievably low for us today. The ceiling was raised above the level of the eaves to form a tray ceiling, to make it a bit cooler and more tolerable.

The starting point of all these houses is the *single house*; it is a concept we will say more about in Chapter VII. We are now going to look at two much larger versions.

The first is the **Principal's Lodge** at **Codrington College**, the home of General Christopher Codrington, the benefactor who bequeathed his estates to the Society for the Propagation of the Gospel for the establishment of Codrington College. (It is not actually his birthplace, as often stated, because his father did not acquire Consett Plantation – later College Plantation – until 1670, two years after his birth.) The house is a single house: one long structure, a single room wide, shown in a 1680 plan to be divided into three rooms on the ground floor – a drawing room, a dining hall (the present stairhall and study) and a servants' hall (the present dining room). The richly carved coral stone of the porch and the balustrades on the parapet are classical Renaissance features imported into England in the late seventeenth century. It is my guess that the porch was Christopher Codrington's, but that the balustrades may have been later embellishments. Old drawings and etchings show a number of different rooflines and do not therefore appear reliable. But parts of the staircase (balustrades and finials) are Jacobean and the heavy, rich details of the carving indicate that it was almost certainly carved by the same artisan who built the extraordinary staircase at Drax Hall in the 1650s, in view of the uncanny similarities. Unfortunately much of it was destroyed by fire.

Bay Mansion in Bay Street was also a single house that has grown. By 1784, it had acquired its present shape – a long cross running East to West –

The stairwell at Drax Hall. The Jacobean staircase, with finials and balustrades, and a richly carved archway of the now extinct mastic wood, are unique in the Caribbean.
(Henry Fraser)

but we can actually see evidence of the original house, in the details of the North wing only, to the left of the grand pedimented and arcaded entrance. The end wall of the earliest structure is undecorated, but joins on the right the newer section, with extensive plaster quoins at corners and windows, and decorative bricks around the cornice which are arranged in alternating fashion and are known as dentils (they look like teeth). By comparing the details of the walls and windows, we know that sometime in the prosperous eighteenth century the massive central block and South wing were added, so that a simple, very basic house was converted into a fashionable Georgian Mansion, which even today is inspiring lavish new mansions on the terraces of St. George and the coast of St. James.

But not all plantation houses expanded on such a massive scale or in such formal style. Some, like **Sunbury** and **Warrens**, remained austere and their exteriors largely unadorned, although Warrens contains fine decorative plaster-work, especially an 'over-mantel' design in the dining room. Most were what Ligon called 'double houses', that is two sections, one behind the other. **Malvern**, in St. John, added a handsome Georgian double porch with quoins at the corners and a curved Palladian double staircase. Later came the verandahs on three sides. Malvern is of particular interest because of several curiosities such as the unique hurricane shelter; it is a two-storey octagonal tower at the back, with walls three feet thick. In the yard below is a handsome stable with regency arches and a plaster family crest of one of its owners.

Alleynedale in St. Peter used to be called Cabbage Tree Hall. It has a third storey or attic with gable windows, which is clearly not part of the original building. Alleynedale is an unusual plantation house not only for its attic and deep cellars, but the profusion of Palladian or Venetian windows, and the solid, long storm-shutters on the outside. It has a fine Garrison-inspired arcaded verandah. It also has a resident ghost – the spirit of an early owner who committed suicide!

Verandahs were added to almost every house; some were of stone, with arches, and some of wood, with turned or carved posts. **Bank Hall**, now the Abundant Life Assembly, has a magnificent stone arcade, as does **Bulkeley** in St. George. Bulkeley was once a centre of political power when sugar was profitable and Barbados' lifeblood. Today it is being restored as a centre for tourism – the new headquarters of Sunlinc Barbados. It is a most appropriate new role for an old sugar plantation great house, since tourism has replaced sugar as Barbados' means of support.

Byde Mill has wooden verandahs over a stone arcade at cellar level, and the entrance has a classic Bajan double staircase. The famous Joshua Steele, FRS and founder of a Barbadian Society of Arts and Crafts, died here in 1796. He was not only an artist and intellectual, but like Christopher Codrington the benefactor, far in advance of the times

The Bay Mansion, Bay Street.
(Felix Kerr)

29 Plantation Houses

Alleynedale Hall, St. Peter.
(Felix Kerr)

Bulkeley Great House, St. George.
(Henry Fraser)

Byde Mill, St. George.
(Henry Fraser)

Indian Pond, St. Joseph – the classic Palladian villa.
(Henry Fraser)

Buttals House, St. George – the arcaded west portico.
(Henry Fraser)

Buttals House from the lawns, showing the rebuilt parapet roof.
(Henry Fraser)

in his thinking. He bequeathed one of his estates, Kendal (the site of the legendary Yarico's Pond[3]), to the two children of his slave mistress Statia, but the law courts overturned it; it was far too radical an idea for them to accept 200 years ago. It is recorded that Steele had erected a 'ready-frame wooden house from North America', and so the present house is almost certainly some time post 1780, that is, built after the Great Hurricane.

Welches in St. Thomas is probably older, built like St. Nicholas, Drax Hall and Warrens at ground level, without any cellars. It is surrounded by wooden verandahs on three sides. Similarly, **Culloden Farm**, Prime Ministers' residence from 1964 to 1976 and now office of the Ombudsman, is also built at ground level, and is embellished with eighteenth century brick dentils, like the Bay Mansion. The wooden verandahs and jalousied window-shutters with half-Demerara hoods are all much later.

In marked contrast to these two-storey houses with verandahs, the classic plantation house style, is the style of **Bagatelle** in St. Thomas. Here there is a basement or storage-cellar; the kitchens are at ground level, and all the living quarters are on the upper floor. This is reached by an impressive double staircase; Palladian in concept (after the style of the grand Venetian houses with the main rooms on the upper level called a *piano nobile*), this style may have been popularized through the Garrison barracks, particularly Blocks A, B and C, with their grand double staircases on the eastern facades. The wisdom of living over the yam store was seen by many planters – it must have inhibited theft – and this style was popular for some of the smaller plantations. It was also the most popular plantation house design in Jamaica. But it was used much more in the old suburbs of Hastings, Black Rock and Belleville. Today Bagatelle is a gourmet restaurant of considerable fame, as are the suburban versions at the Virginian Restaurant and the Great Escape.

Newcastle in St. John has had no such luck. Its elegant Georgian architecture with panelled arched windows was probably the work of General Robert Haynes, who was a major sugar baron of the eighteenth century. In recent years, it was acquired by Government and became the Newcastle Children's Home. In 1985 it was closed, and one can see the rapid decay and the vandalism which are as wasteful as destruction by hurricane. It is a tragedy and a shocking waste of a valuable building.

Newcastle's parapet roof suggests it was rebuilt after either the 1780 or 1831 hurricane. The parapet wall protects the roof from high winds. Some houses tell the full story of hurricanes. **Buttals** in St. George, for example, is clearly an eighteenth century house with handsome quoins, and an arcaded Georgian porch, but if you look closely at the corners of the building, you can see that the upper wall was rebuilt as a parapet to protect the roof, and the builders did not bother to put back the quoins. Exactly the same thing happened at the

Harmony Hall (now Solidarity House) as it was in 1953.
(Felix Kerr)

Halton Great House, St. Philip.
(Henry Fraser)

Farley Hill from the north lawn, showing the bow front of the dining room and library.
(Felix Kerr)

B.W.U.'s headquarters, Solidarity House, formerly **Harmony Hall**, which survived the 1780 and 1831 hurricanes.

Halton Great House, on the other hand, was entirely rebuilt after the 1831 hurricane, with the verandah almost certainly built at the same time, over wide arches which ventilate deep cellars. It is a striking building, Georgian in its perfect symmetry and proportions but 'Barbadianised' with its cellars and wide open verandahs. At the back is the traditional long kitchen wing to keep the smells and fire hazards as far away as possible. There are Speightstown-style dormer windows at attic level and a ten feet tall stair window.

Highgate in St. Michael may be the prototype of most of our plantation houses. It is an eighteenth century house with Georgian details, and the floor plan and other features appear again and again in later houses with monotonous regularity until early in the twentieth century. It is now

Wakefield, St. John, among the ubiquitous cabbage palms that abound in the country parishes.
(Henry Fraser)

undergoing restoration by new owners, with replacement of the elegant cast-iron balusters, to re-instate it as one of the finest of the smaller plantation great houses.

Highgate has ornate plaster ceilings in common with Sam Lord's, Canefield House, Verdun (the nineteenth century great house which became the staff quarters of the now closed Presentation College in St. John), Warrens, Erin Hall (more recently Alexandra's Night Club, now closed) and the ruined Farley Hill. But Sam Lords and Farley Hill were mansions of an entirely different scale and concept, possibly rivalled only by Government House or by Devon House and Rose Hall Great House in Jamaica.

As we come to the end of our survey there is no doubt that **Villa Nova** does represent the true high point in the metamorphosis of the classic plantation great houses. It is clearly built to withstand the mightiest hurricane, with two feet thick walls and a parapet roof. The verandahs culminate on the South side in an elegant porch, with a bow front, perhaps copied from Government House and copied in turn at Farley Hill and the Bay Mansion.

Villa Nova was for many years the residence of

Harrismith, St. Philip – a plantation-style sea-side mansion, built by the owner of Wakefield in the period of post-World War I sugar prosperity.
(Felix Kerr)

the parish doctor for St. John, since 1907 when it was separated from the plantation. We kids would have to wait here by the surgery door of the late Dr. Bertie Carter, scared perhaps, but comforted by all the country noises of blackbirds and frogs and the wind in the trees, waiting for old Dr. Carter's friendly pat on the back and his famous painless injection, given with a rub and a sharp slap, a quick jab and a chuckle! And then, with a bit of luck, you might be chased away to go and pick some cherries.

Today, Villa Nova is world famous as the one-time home of Sir Anthony Eden, Britain's Prime Minister. It has been visited by queens and princes, by politicians and tourists from all over the world and is loaned as a 'special' Open House for the Barbados National Trust for one day every year.

But not every plantation house can be a 'Show House', and many, large and small, are now in ruin or under threat. They are being sold off to keep sugar going, and used for orphanages and offices, churches and schools; sold to merchants and manufacturers as homes; to doctors and lawyers, politicians and priests; to singers and sailors; and some to butchers, bankers and no doubt candlestick makers; but most important, they can now be of the greatest value as historic sites and showplaces. It is an interesting irony that these unique products of the sugar industry, for which our forefathers laboured, are now so valuable to our current life-support system – tourism.

From every point of view, aesthetics, heritage, craftsmanship or economics, they are *Treasures of Barbados*.

Chapter VI

Historic Bridgetown

For most Bajans, and indeed most visitors, Historic Bridgetown means the Public Buildings or Parliament Buildings which look terribly old because they are built in neo-Gothic style, that is a nineteenth century recreation of medieval church architecture, with its gothic arches, perpendicular lines and rich stone carvings. In fact, they date from the early 1870s and were built, at a total cost of £25,000[1], on the site of the New Burnt District, part of ten acres destroyed by fire in 1860[2]. This was only the last of many big fires which ravaged the city over the centuries. As a result, few of our buildings date from before 1845 in Lower Bridgetown, or 1860 in Upper Bridgetown. To the uninitiated, 'lower' and 'upper', like 'below' and 'above', are descriptive terms which only a Bajan born and bred understands exactly and which no amount of explanation will teach to the non-Barbadian. Some hold that 'upper' means to the East or North or North East, or to the windward (and less often at a higher level), or a combination thereof.

Trafalgar Square from the top of the National Insurance Building on Fairchild Street.
(Felix Kerr)

The heart of Bridgetown: the Chamberlain or Swing Bridge on the far side of the Inner Basin, and part of Trafalgar Square on the right.
(Felix Kerr)

But we can piece together the building history of Bridgetown from various shreds of evidence. We know the early houses were of wood. In 1668, a fire destroyed 80 per cent of the houses. As a result a statute was passed specifying that all new buildings be built of stone – a radical, very early piece of Town Planning Legislation that had a major impact on the appearance of Bridgetown.

The best picture we have of the city is a meticulous engraving at the Barbados Museum, by Samuel Copen, a Barbadian Schoolmaster, in 1695. It is called 'A prospect of Bridgetown in Barbados', and shows tall gabled buildings with an obvious strong Dutch influence. It was described around that time as 'a popular though somewhat confused town'. The Sailmaker painting of around 1694, in the Aall Gallery at the Museum, is a bit of fantasy painted by a Dutchman who might have seen Copens' drawing. The next accurate depiction we have is the Robinson painting in the Cunard Gallery of Governor Robinson going to Church in 1642. Again the prominent Dutch gables – stepped gables and curved gables – can be seen all over the town.

There is little doubt that the oldest surviving building in Bridgetown is that known as the **Nicholls' building** on the corner of Lucas and James Streets, named after the father and son dentists Nicholls who pulled, filled and capped many a tooth here between the 1930s and 1950s. (It is now law offices called Harford Chambers, after the distinguished headmaster of Foundation Boys School, the late Lee Harford Skeete.) It has the classic Dutch gable, with particularly sensuous curves, and with an attic 'loading' door in the centre. The Dutch developed a characteristic style of architecture in the seventeenth century, described as gay and boisterous, with voluptuously decorated gables. The door to the loft was fitted with a winch or a counter-weight system, so that goods and furniture could be hauled up the front of the house from the street to the attic or loft (good examples can be seen in Curacao). When Bridgetown was rebuilt after 1668, trade with the Dutch was at its height, so no doubt everything Dutch was best; it was just like some Bajans' preference today for everything American – a different age but the same kind of attitude. So this building is not Huguenot as has been suggested[3], but a direct legacy of our strong Dutch links of the seventeenth century.

This building is the only *obvious* seventeenth century relic in Bridgetown. Almost everything else from that period has been lost, although I believe that the adjacent building on Lucas Street, insensitively altered a few years ago, is of about the same vintage.

Across the road is an elegant three-storey building, with New Orleans style cast-iron balconies, thought to date from the 1840s. There is a broad archway entrance to a courtyard behind, and

Cast-iron balcony of a building on the corner of James and Coleridge Streets.
(Felix Kerr)

MacGregor Street. Believed to be the site of Betsy Austin's Clarence Hotel.
(Felix Kerr)

an adjacent entrance on the long side of the building to the stair hall, with an elegant stairway and balustrades and beautiful doors and fanlight.

On the opposite side of Broad Street, on the west of MacGregor Street, are several buildings of similar style to the Nicholls' building, with low ceilings and prominent quoins around the windows, although they have recently been painted over.

At the end of MacGregor Street is a beautifully preserved classic, now occupied by Dominoes restaurant and the Food Basket. Note how the building fits the street, and note the third storey gable windows or dormer-windows (there are only a few left in Bridgetown) and the beautiful arched doorway.

Those were rough pioneer days in Barbados; men were lewd, boisterous and quarrelsome and punishment was swift and brutal. John Wiborne was nailed to the pillory by his ears with ten penny nails (6 inches long) for libelling one Master Hilliard, and *then* he was whipped and branded! Captain James Fuller asked Judge Read in open court: 'If all the whoremasters were taken off the bench what would the Governor do for a Council?'

No wonder that the **Town Hall Jail** and **Court House**, built in 1730, was such a large and impressive building. There is a water-colour in the Barbados Museum painted by Richard Jewitt, an American held in Bridgetown as a prisoner of war in 1813 (during the Anglo-American War). It is an important record of an important building, which was obviously the finest civic building for the next 100 years. There is a grand central pediment and a round window with a Celtic cross keystone arrangement, a motif you can see copied in every gable end and pediment around Bridgetown for years thereafter.

The **Court House** or **Law Courts** building was ravished 40 years ago by the invagination of a long upstairs corridor from the Registrar's Office into the pediment and central hall – an atrocity surpassed perhaps only by the bulldozing of Holborn House (the first official Government House) and Codd's House (site of Parliament from 1837 to 1848 and demolished on 11 May 1985, without public notice). We can only, therefore, see its eastern flank from the road. The flattened arches and the dentils of the cornice are reminders that this was a gem of a building, to be proud of and not scandalously neglected as it is now.

Brick dentils were a popular eighteenth century ornament, and a few survive on old shop houses in Roebuck Street and Swan Street. But with the holocaust of 1766 razing 1140 buildings and half-a-million pounds worth of property, many other fearsome fires, and two great hurricanes in 1780 and 1831, we can find only a few other early buildings with such details, particularly a few in Lower Bay Street. The **Boatyard**, for example, has a narrow building, a single room wide, with a gallery down the long side to the yard, and a stairhall in the centre, recently demolished. (It is a house style exactly like the famous single houses of Charleston, South Carolina, settled largely by Barbadians.) Next door is another early style with rounded corners, which may have been inspired by the Jewish Synagogue, destroyed in 1831 and rebuilt in 1833. Across the road is the **Exchange** which was the business place of London Bourne, the most famous and wealthy black Bajan merchant of the mid-nineteenth century. Born a slave, he owned Friendship Plantation and many city properties.

Around the bend on the sea side are three houses often known as the South Entrance to

The Law Courts, Coleridge Street.
(Felix Kerr)

Carlisle View and neighbours, Lower Bay Street.
(Felix Kerr)

The Martineau House, Bay Street and Beckwith Street.
(Felix Kerr)

Bridgetown. **Carlisle View** is a classic Georgian house, said to have been built by a sea captain before 1841. Next door is the delicately decorated house, **Lynton**, built for the sea captain's daughter, and a third house – both of these in traditional Bajan town house style, with balconies, carved wooden support brackets and the unique, curved Bajan parapet on the street façade.

An even finer example a little further on is the **Martineau House**, built in 1860. J. A. Martineau, vestryman, social reformer and soft-drink manufacturer, was a leading spirit in Charles Duncan O'Neal's Democratic League and the Barbados Progressive League (Barbados Labour Party) which was founded and which met in his house, now the Book Place (a bookshop specializing in secondhand, antiquarian and West Indian books).

Note again the curved parapet and the verandahs, open over the main road and closed to the East with Demerara windows to keep out the rain. Note, too, the decorated bell pelmets. All these features closely resemble those of the other known 1860 buildings along Lower Bay Street, rebuilt after the fire.

Another landmark from around 1800 is the former **Savoy Guest House** (of the St. Lucian Zephirin family) which was vandalized and then restored five years ago for the Child Care Board. The Savoy was a classic, though modest, example of Georgian architectural style, with the addition of the 'tropical' verandah.

This kind of progression, from eighteenth century town house to the oldest suburban styles can be seen on all the main roads out of town. By

The Savoy, now the Child Care Board. Note the extension on the right, with dentils but without the necessary window hood.
(Felix Kerr)

Roebuck Street.
(Felix Kerr)

Moll's Alley, off Spry Street.
(Felix Kerr)

41 Historic Bridgetown

The Waterfront.
(Henry Fraser)

Dacosta's elegant Georgian warehouse, minus the balcony.
(Felix Kerr)

St. Michael's Cathedral, for example, is the charming and very obviously eighteenth century building of the antique shop Antiquaria – of thick rubble and brick walls, with low door and windows, half-gable attic windows and a pre-1831 roof with no parapet. Beyond were the old suburbs: an elegant Edwardian house, now Fine Art Framing, and a Bajan classic with white-painted jalousied gallery and porch, for generations doctors' offices.

Baxters Road and Tudor Street on the west side, and Roebuck Street on the east side have, perhaps, most of the old balconied buildings; this is the best of the streetscape that was Bridgetown for 200 years. These buildings *are* the Bridgetown our fathers and grandfathers knew: the food shops, the grog shops, the dry goods shops, the hardware shops and the 'Doctor shops' of past and present. They are the real soul of the city, as much as the Cathedral or St. Mary's Church. And when you leave the historic Roebuck and wander through Spry Street and Moll's Alley with its exquisite row of ancient Georgian style town houses, or Palmetto Street with its Victorian balconied shops, you must have respect for our forefathers' craftsmanship and their struggle that made our lives possible.

Another face of Bridgetown is that of the

sturdy warehouses of the wharfside. Known as bonding warehouses or bonds, they line the south side of the Careenage, from the Dry Dock to the now famous **Waterfront Cafe** and Warehouse Restaurant and Night Club. Here, just four years ago, historic Bridgetown came alive with a vengeance, with our first waterfront eating place. On the north side were more warehouses – including the old Spirit Bond and Customs House, now a sad derelict: of uncertain age, but solidly built, entirely of brick, and abandoned by successive governments.

Further North is the original **DaCosta's Warehouse** which was perhaps the finest building in Bridgetown, according to Acworth in 1949, when it still had its original balconied façade[4], as it was then. It has lost the balcony but gained the Atlantis submarine, or at least its office! The cast-iron gates in each of the five superb arches are magnificent.

Around the corner is Hincks Street. At the far end is **Musson House**, a recent 'rehab' job with a fine rose window and an elegant shopping mall. In the middle is the now tragic-looking **Marshall Hall**, once the pride of Bridgetown. Built in 1861, this was the equivalent of the Marine Hotel Ballroom and the Frank Collymore Hall rolled into one. Its robust sawn stone design with parapet roof, rounded corners, flattened arches and jalousied windows are the best of Bajan building in the eighteenth century, and it witnessed every major social event, from balls to the annual exhibition for many years.

At the south end is the **Carlisle Bond**, a visually energetic row of gabled warehouses. Simple, large, robust buildings, with strong lines and a few striking arches – they epitomize the importance of trade in Barbados. Happily, after the rave success of the Waterfront Cafe, they will soon be restored as a shopping mall, as was DaCosta's elegant main store on Broad Street which reopened as a mall in 1989.

Bridgetown has its fair share of show places, not only the big warehouses and the Public Buildings but some great churches too: the Cathedral, St. Mary's Church, Calvary Moravian Church, the Carnegie Free Library facing the ornate Montefiore Fountain, the unique Barbados Mutual building, with its twin orbs of silver and exquisite Victorian cast-iron work. It has also some buildings which were once fine and are now sadly forgotten, like the Old Town Hall or vestry building, opposite St. Mary's Church. For nearly a century, this was the Vestry Hall of St. Michael and the Town Hall when Ernest Deighton ('E.D.') Mottley was Mayor. It was 150 years ago the site of Hannah Massiah's Hotel and the centre of the hotel district; next door were the hotels of Sabrina Brade and Hannah Lewis, legendary innkeepers. With its massive walls

The Vestry Hall and Town Hall, by St. Mary's Churchyard.
(Felix Kerr)

Suttle Street.
(Felix Kerr)

and arches, cantilevered balcony (recently torn down) and superb staircases, this was a building to be proud of, but it is now a disgrace and a cause of national shame. We weep for the Town Hall. As the former centre of local government, it deserves similar respect to the Public Buildings.

With the triquintennial of Parliament in 1989 (350 years of Parliament) the **Public Buildings**, recently formally renamed **Parliament Buildings**, are being restored. With the fine clock tower, handsome arches and iron work, the unique jalousied version of oriel windows, and the profusion of rich stained glass windows, they have been the centre of Government for 125 years (see Chapter XII). With the famous statue of Nelson standing guard, as it were, in Trafalgar Square, this is perhaps the most famous and the most photographed historic site in the Caribbean, and certainly one of the most attractive and interesting town squares in the region.

With the Waterfront across the Careenage, Bridgetown can now boast one of the finest historic city centres in the Caribbean. And I have a dream that if a little of the many millions our Government spends on new buildings can be spent in the right way, Historic Bridgetown will be known far and wide. The whole city will be a *Treasure of Barbados* and the Caribbean.

Chapter VII

Historic Speightstown

Arlington, a medieval style 'single house'.
(Felix Kerr)

Historic little Speightstown, to use its proper name, is Barbados' second town. In spite of the spelling Bajans have called its 'Spikestown' right from the start. The name comes from William Speight, a local merchant and a member of Governor Hawley's first parliament in 1639. Speight owned land here, and early records refer to Speights Bay. But Richard Ligon, that erudite historian, artist and architect who came to Barbados in 1647, showed it as Spykeses Bay in his map, and we have pronounced it 'Spykes Tung' ever since!

Barbados was well protected by its coral reefs and dozens of forts. Speightstown had Orange Fort, right in the centre of town, by the fish market, Coconut Fort and Denmark Fort. On the old sea cliff to the East, overlooking the town, was Dover Fort (or Dover Castle), and a short distance to the North was Heywood's Battery.

Few Bajans realize we were ever invaded, but Speightstown was actually the site of the one and only invasion of Barbados. When Oliver Cromwell deposed King Charles I, most of the powerful Bajans sympathized with the Royalist cause. But some of the more radical, like Colonel Alleyne, took ship to England, afraid of reprisals by the Royalist supporters. Cromwell sent Sir George Ayscue with a fleet to bring the Bajans to heel. After being repulsed in Carlisle Bay, Colonel Alleyne led them ashore here in December 1651. He, poor fellow, was felled by a musket ball on the beach, but the landing was effected, and to cut a long story short, Lord Willoughby capitulated, possibly on the advice of his wife back in England[1].

Spikestown was then at its height. Because of a huge trade with Bristol, it was known as Little Bristol. But it seems it has been downhill all the way since then. For many years most trade and communication with Bridgetown was by sailboats called schooners, and there were four jetties in the bay; the last one, Challenor's, was closest to the present fish market at the site of the old Orange Fort.

When a town declines, it draws the cloak of the past around itself, and until 20 years ago, most of old 'Spikestown' had hardly changed from an eighteenth century seaport. A fire in 1941 destroyed almost everything near the bridge on Queen Street, but old photos show us the character of Speightstown which is recorded too, in the prolific paintings of Speightstown's own artist Ivan Payne.

That character remains strongest in four parts of the town, all very close together:

Original Alexandra School building.
(Felix Kerr)

The South end of Queen Street, including Arlington, the Old Health Centre;
The Old Library and its neighbours, and the Noel Roach Pharmacy;
Church Street, and
Sand Street, originally Sandy Street.

Arlington, the old Health Centre, is certainly one of the earliest and one of the most important houses in Speightstown. It is very much a medieval type of house, tall, narrow and gabled, with a third floor attic and gable windows. It is typical of the seventeenth century town houses we know once existed in Bridgetown, and like the *single house* described by Ligon in 1650. It is in fact the very dimension, 22 feet wide, of Ligon's recommended house, although its shape is irregular; it tapers to the back, like many medieval houses, and it has a very medieval feature, a stairhall as a separate wing at right angles to the main structure. It is a single room wide, with a shop on the ground floor, and a grand street entrance. It was probably a ship chandler's (a firm which stocked or outfitted ships) and the owners, the Skinner family, had their own jetty. There is an upstairs entrance to the drawing room above, with verandahs down the long side to the garden. It is now the Lions' Den for the North. The gateway and staircase is a very grand feature, and is the best preserved example of a typical Speightstown outside staircase. Other examples can be seen in Church Street.

Arlington closely resembles the *single houses* of Charleston. Bajans were largely responsible for settling Charleston; Bimshire was, if not the mother colony, then the foster mother of the Carolinas[2]. Barbadians, aided and financed by wealthy Londoners, explored and settled the Carolinas. They took the lead in its affairs from the settlement of Charleston in 1670 until the middle of the eighteenth century.

Across the road are typical old Speightstown houses, separated by the site of a fire caused by a burning bus. There is an old warehouse, and a classic three-storey shop house with a closed gallery. This house was once the Alexandra School for girls, which may explain why the gallery was discreetly enclosed. It has just been restored for an upmarket commercial use, one of a booming chain of video shops.

Nearby is perhaps the grandest old building left besides the parish church: the old **Post Office** and **Library building**, and once the telephone exchange. It is pure Georgian – perfect symmetry with little ornament but an elegant gallery and staircase and it overlooks the sea at the back.

Past the new Speightstown Cave Shepherd Mall and the redesigned Barclays Bank building is the **Noel Roach and Sons Pharmacy** or drugstore, a classic and perfect Speightstown prototype, with the tower of St. Peter's Church in the background. This magnificent building has three storeys, gable windows and walls 28 inches thick. It contains original beams and is built of ballast bricks from

Post office, library and telephone exchange.
(Felix Kerr)

Noel Roach Pharmacy.
(Felix Kerr)

Ancient buildings, modern colours (Sand Street).
(Felix Kerr)

Church Street's derelict classics.
(Felix Kerr)

Bristol. Note the large gable windows, or dormer-windows, and the flattened arches of the windows and doors. Its verandah is supported by classic carved wooden brackets. It has neither damp nor cracks, and is roofed with indestructible 14-gauge galvanised iron sheets. At the turn of the century it was Farnum's pharmacy, later Archer's, then the old Post Office and Barclay's Bank's first branch. It has been Noel Roach and Sons for over 50 years.

Further North, on Sand or Sandy Street, we come to a cluster of very ancient, very low houses. Beyond are two buildings known for many years as **Mike's Place**, two very fine buildings with traditional verandahs, and a panoramic view of the sea.

On Church Street are more of the classic Georgian buildings, with Bajan verandahs, but they have been virtually abandoned. Only their dignity holds them up. Once elegant shops with homes above, they have been left to crumble. Some have been replaced by modern misfits, totally insensitive to the traditional ambience and the 'once and future' potential of the street.

Fire has destroyed several old buildings over the years, and has recently destroyed Manning's warehouse. Speightstown has further chances to rebuild and restore. Will it be faithful to its unique traditional architectural heritage? Will it capitalize on its tourist role and restore its historic image?

It is only yards away from Heywoods Resort. Tourism today is integrally linked with historic sites, like historic London with its famous Tower and palaces, El Moro Fort and Old San Juan in Puerto Rico, The Citadel in Halifax. Castles and houses of great men, old towns and warehouses all over the world have become major attractions for tourists, and old buildings on waterfronts are a sure success, from New York and Baltimore to the Rock in Sydney Harbour, and now the Waterfront in Bridgetown with its Waterfront Cafe and Warehouse Restaurant and Night Club (struck by fire in October, 1989). A restored Speightstown would be Heywoods Resort's main attraction.

'Spikestung' has a rich heritage, even in language. For do you know what a 'Spikestown compliment' is? Frank Collymore, father of Barbadian and Caribbean literature and founding editor of *BIM*, the literary magazine, tells us that it is the local term for a left-handed compliment – perhaps because Speightstonians were supposed to be less urbane than dwellers in the metropolis[3].

Speightstown is perhaps the only significant

Six Men's jetty – the last of the Speightstown to Shermans jetties – redundant when the schooners disappeared.
(Felix Kerr)

relic of the old seafaring days in the region, with the exception of the magnificent English harbour in Antigua. Imagine the impact of restoring the rest of Speightstown like the beautiful balconied buildings at the north end of Sand Street and the opening up of the beautiful beach with a tree-lined esplanade all the way from Heywoods Resort. Imagine a rebuilt jetty on the old site of the Challenor Jetty, next to the Fisherman's Pub and the Fish Market, with the romantic schooners like 'Silver Heels' and 'Lady Sandford' sailing into 'Spikestung' once again, with tourists and locals alike. It was bustling Little Bristol 300 years ago, a ghost town 30 years ago, struggling now; can we bring it back to prosperity? Speightstown is unique in the West Indies, and with just a small portion of the many millions our Governments spend on a single new building today, we could restore the charm and prosperity of Speightstown and make it truly a *Treasure of Barbados*.

Chapter VIII

Suburban Houses

The most famous Bajan house forms are the wooden chattel house and the coral stone plantation house. But there is a third type of house that is also unique to Barbados: our traditional suburban house.

The word suburb itself is worth a closer look. It comes from two Latin words – 'sub', meaning under or near to, and 'urbs', the city – literally 'under the city walls' or 'next to the city'. Apparently, in seventeenth century London most of the prostitutes stayed outside the walls and the term 'suburb woman' was used for a lady of the night. Three hundred years ago, the word 'suburb' itself used to mean a place of 'inferior, debased and specially licentious habits of life'. But its use and meaning have gradually changed. Today, it has a more salubrious, desirable connotation, although suburban life is often said to be dull, perhaps compared to the more licentious and colourful life of the past!

Bridgetown's suburbs have grown in four clearly defined stages.

- First, the slow expansion from the old town centre along the main roads: St. Michael's Row towards Queen's Park, Cheapside towards Fontabelle, and Bay Street where upstairs town houses or shop houses gave way to residences.
- Next came the planned suburbs. Belleville really set the pattern over 100 years ago, although little villages came 50 years earlier at Hastings and Worthing.
- Then came the steady urban sprawl that began on the highways of Two Mile Hill and Bank Hall, Spooner's Hill and Black Rock, Collymore Rock and Hastings.
- The fourth stage is the rapid spread across the plantation lands of Warners and Coverley and Frere Pilgrim in Christ Church, Warrens and Clermont in St. Thomas, filling in everything South and West of the new Adams–Barrow–Cummins Highway and beyond.

The first three stages took well over 100 years, and during that time the classic style held sway. We can trace its development in two ways; literally by following the main roads out of Bridgetown, and by studying the houses whose dates of building we know.

Cheapside, for example, was a typical business district, with shops downstairs and merchants living above. Each had a balcony for the family to cool out and catch the breeze, and to shade the

Classic Cheapside cottage.
(Felix Kerr)

shoppers below. Note the square parapet on the first building in Cheapside, rebuilt by Percy Hinds, but the curved or scalloped parapet on the others to the West, going towards Fontabelle. Also as you go West, the shop houses give way to residences, most of them of one storey, in the classic style but with the concretisation of Cheapside (and Fontabelle) many of these houses are now derelict. Beyond was the wealthy suburb of **Fontabelle**, the last and best of which was the superb Woodville, once the Cosmopolitan Guest House. This beautifully proportioned house with its cast-iron verandahs and double staircase would have been, and still is, a very special landmark house.

On the other side of town, in **Bay Street**, the old town once ended with two-storey shops like the Boatyard with its square parapet, and the wealthy black merchant London Bourne's house, the Exchange opposite. These gave way to residences at several points – as at Industry Cot, near Woodside – and of course, the magnificent Woodside itself, home of Lady Scott and the late Sir Winston Scott, our first Barbadian-born Governor General.

Past the Garrison is the early nineteenth century villa, Parade View, now the new **Virginian Restaurant**. Its Palladian double staircase and parapet were almost certainly the model for the little village at Hastings – classic villas built soon afterwards, beyond the Military Hospital, now Pavilion Court.

Perhaps the best of the 11 original Hastings village houses is the superb **Villa Franca**, where Mr. Pearman opened his famous bathhouses in 1833. The pair of bathhouses over the water, one for men and one for women, approached by a divided jetty, survived until Hurricane Janet in 1955.

Villa Franca is the prototype Palladian villa – a double staircase with a central arch and an elegant portico, and a jalousied verandah or gallery, a distinctively Bajan feature, as opposed to the more common open verandah elsewhere in the Caribbean; it is perhaps an expression of our more private, conservative approach to life. (Barbadians tend to use the word gallery for this narrow front room if it is enclosed with jalousies or alternating jalousies and sash-windows, but retain the Hindi word verandah if there are posts or arches and no enclosure.) Villa Franca, like many of these houses, is decorated with the Regency design recessed panels, introduced at Sam Lord's Castle in 1820, over a handsome arcade at ground floor level. A stone

The Virginian Restaurant, the restored ruin of Parade View, the Garrison.
(Felix Kerr)

Villa Franca, Hastings.
(Felix Kerr)

parapet protects the fish pond roof. Note the square corners of the parapet in this 1830s house. Just three years ago, Villa Franca was a wreck: it has now been meticulously restored for office use and has received a National Trust Restoration Award for an outstanding rebirth.

Going East from Bridgetown along **St. Michael's Row**, ancient shop houses give way abruptly beyond the Cathedral to some of the early suburbs. First is a classic suburban house of the early nineteenth century, for years a doctor's surgery. Again note the square corners of the parapet. Beyond is an Edwardian house, restored as an Art Gallery.

Beyond Queen's Park is a row of proud chattels and cottages with verandahs, leading to the outstanding row of villas on Belmont Road opposite Belmont House.

Belmont Road alone tells the story of the suburban house. Here is a complete range of nineteenth century houses, from the finest with its ornate gateway to the smallest chattel. These are the prototype suburban classics, with double staircase and jalousied gallery, and every variation of size and detail. The Belmont streetscape is really a lived-in museum of suburban architecture, and is one of our best streetscapes; it is, perhaps, the only street with five unaltered houses of more than 100 years in age, next to each other.

Close to Belmont Road is **Belleville**, deriving its name, it is believed, from neighbouring Belmont. Belleville was the brainchild of the brilliant entrepreneur Sam Manning; it was Barbados'

Early suburban house, St. Michael's Row.
(Felix Kerr)

Belmont Road villas.
(Felix Kerr)

first planned suburb, laid out in 1885. What Sam Manning did was to landscape it with mahogany trees and hundreds of royal palms, and provide plots of every size for (almost) every pocket: from the elegant Holyrood (Fourth Avenue) or Ronald Tree House, The National Trust Headquarters, the former Chief Justice's House on Second Avenue, or Smith and Oxley's headquarters on the corner of Eleventh Avenue, to the George Street cottage – from the very tiny to the medium-sized.

But the majority were identical to those at the western end of Belmont Road. Was the same builder employed? Was the Belmont design the official model? All have central entrances and a gallery with rows of alternating jalousies and glass sash-windows. The bigger ones have another floor below, like the Great Escape restaurant on First Avenue and George Street, a grand double staircase and the Barbadian bell pelmets or window hoods. And all have the unique curved or scalloped 'Bajan parapet' which appeared after the 1840s and was more or less mandatory by the 1890s when most of Belleville was built. We can only guess who built the first one and why; maybe some stingy builder wanted to save a few stones, and literally cut corners, but the resulting design became almost a national symbol!

Of course, Belleville is remembered as an enclave of the privileged middle class, but it also became a kind of sheltered village for the elderly, with small houses for retired teachers, civil servants, spinsters or artisans, living very much by their wits in retirement, as well as a stepping stone for newly-weds to the more ostentatious parks and terraces.

Ronald Tree House, headquarters of the Barbados National Trust, Belleville.
(Paul Foster)

The Great Escape, Belleville.
(Felix Kerr)

Today, Belleville still shelters elderly, low-income people, and many houses are in desperate need of restoration. Businesses have moved in, sometimes with magnificent results but sometimes with results that are aesthetically disastrous. Can the finest of these examples, like the **Smith and Oxley building** (the trendsetter), **Ronald Tree House** and the **Great Escape**, be followed, to preserve a unique living historic site as a Conservation Area?

Soon after Belleville came fascinating Strathclyde which could be called the village of walls; then beyond Hastings came Marine Gardens. Between Villa Franca at Hastings and Maple Manor are a dozen gems, from the ornate replica of Queen Mary's Dolls' House to the many classics of Bajan vernacular: **Mervue**, (the Caribbean Tourism Research Centre) which is a plantation-style house with galleries surrounding it, and **Maple Manor** itself, which has gone full circle. Modernized a few years ago, it has just been restored and further embellished with a traditional style balcony. In fact, the traditional or vernacular is now inspiring new versions of the best old styles in many new buildings. Shakey's Pizza House, for example, is a fine interpretation of the suburban classic.

Of course, not everything old was typical Bajan vernacular. Emigrants who made good overseas sometimes brought back exotic foreign styles, hence **El Sueno** in Worthing, built soon after 1900 in Spanish style, with ornate balustrade garden walls. Then there is the house known as **The Trinidadian House** at The Stream (Worthing), a typical richly decorated Trinidad Carnival of a house, now

The 'Trinidadian House', Stream, Worthing.
(Felix Kerr)

Rus in Urbe, Crumpton Street.
(Felix Kerr)

in need of restoration. Similar 'borrowings' are seen in Upper Bay Street and near Speightstown.

In Crumpton Street, Guyanese and Bajan cultures meet. The most prominent house was built in the 1830s or earlier, in what was then countryside, before Crumpton Street was cut. Hence the name **Rus in Urbe** which means 'Country in the City'. It was embellished in the 1920s with lavish Guyanese fretwork and Demerara windows, inspired by the cast-iron work exported from Glasgow and the Midlands. Rus in Urbe undoubtedly has the finest wooden decoration in the country, the city or the suburbs!

One of the most interesting features of traditional suburban houses is the influence of the craftsman on the house of his patron. The modular chattel house, so uniquely Bajan, has actually had a major influence on the middle class suburban home: it has been reproduced in all sizes, in stone and in wood, all over Bank Hall and Belleville. Suburban houses, inspired by the same modular design, were given the same symmetry and gables, porches and pelmets as the carpenters' chattel house, but on a larger scale. This is an unusual phenomenon because it is the architecture of the gentry which is usually copied; but here we have the opposite – folk architecture influencing the bigger suburban houses.

It is just one of the many fascinating things about the heritage of Barbados; its built landscape is a rich tapestry, telling the Bajan story, and if we look around us with a curious eye, we realize how many of the things we take for granted are really unique to this island – they are truly *Treasures of Barbados*.

Suburban villa, chattel house style.
(Felix Kerr)

Uniquely Barbadian suburban classic at Skeete's Hill, Worthing.
(Felix Kerr)

Chapter IX

Houses of Leaders

Culloden Farm.
(Felix Kerr)

Houses help to tell the story of men who stood out from the crowd. On Independence Day 1988, *Treasures of Barbados* looked at some great Barbadians of the past, and the places where they lived.

The stories of great men may live on for many years. Their stature may be enhanced or may diminish with time. This selection was considered from all angles, not just as super heroes who could do no wrong, but simply as some of our greatest leaders, who left their country better for their presence. In selecting this personal pantheon of great Barbadian men and women, I have set five criteria: they must be indisputably patriots; they must have inspired widespread praise and admiration; they must have left their mark on the society; their birthplace or major home must be known, and they must have gone beyond this vale of tears. And where better to start than with the man who led Barbados into Independence: the late Errol Walton Barrow.

Errol Barrow became Premier in 1961 and was our first Prime Minister from 1966 to 1976. He returned to power, already the Caribbean's respected elder statesman, in May 1986. Errol Barrow urged us to draw on our cultural heritage, and among the many sensible, practical things he did was to establish an official Premier's/Prime Ministers' residence. This house, **Culloden Farm**, off Culloden Road and Collymore Rock, was the house he chose in 1964 and which he occupied until 1976. It is a solidly built plantation house, secluded 'like country' yet within a mile of central Bridgetown; it was a perfect choice. In every way, in every door and window detail, it epitomised good, traditional Barbadian design, set in a formal nineteenth century garden.

Barrow was actually born at the Garden, in St. Lucy, a small plantation or farm belonging to the O'Neales, his mother's family. (See Chapter V.) The Garden House is a very old small plantation house. Its rubble stone walls are two feet thick. The low hip-roof has traditional tray ceilings, to raise the height of the room. It is little changed today.

If we look back from 1966, two great men stand out in the pre-emancipation period of history. The first is **Christopher Codrington**, the Benefactor of Codrington College, Fellow of All Souls and Public Orator at Oxford, English Army General, Governor General of the Leeward Islands. Codrington was described as Barbados' greatest ornament – a born leader of men, a

scholar, a minor poet and a wit. His whole life was brilliant but kaleidoscopic; he died aged 42 at Consett (now the Principal's Lodge of Codrington College) in St. John, where his bust now stands in the Great Hall of the College. But his fame and place in history rest on two things: his bequest and his benevolent attitude to his slaves. He left his estates, Consett's (known as the Lower Estate) and Codrington (known as the Upper Estate and later as Society Estate) to the SPG (The Society for the Propagation of the Gospel). From the revenues they were 'to create a college for scholars under vows of chastity and obedience, for the study and practice of physick, surgery and divinity, that by the usefulness of the former they may have better opportunities of doing good to men's souls while taking care of their bodies'.[1]

Codrington lived at the original Consett's mansion house or great house from 1707 until his death on Good Friday, 7 April 1710. The College buildings were built alongside. They were completed in 1743, and a grammar school (now the Lodge School) opened on 9 September 1745. **Consett House** became the Principal's Lodge for the school and later the College. Steeped in history, it is also an architectural gem although it lost its roof in

The Nightengale Children's Home (Belfield, Black Rock), home of Samuel Jackman Prescod.
(Felix Kerr)

Mottley House, once the home of the Rev. James Young Edghill, and site of *The West Indian* newspaper when he was the editor.
(Felix Kerr)

the hurricanes of 1780 and 1831. Its plan and staircase are of particular interest[2].

Closely associated with Codrington College was **Sir John Gay Alleyne**, Speaker of the House of Assembly for 30 years, and member for 39. He should be remembered not just by his home, **St. Nicholas Abbey**, but for securing the famous three parliamentary privileges – freedom from arrest, freedom of speech and freedom of access at all times to the King's representative. He established the Alleyne School as a free school. He lived from 1746 until 1801 at St. Nicholas Abbey.

After emancipation, the peoples' hero was **Samuel Jackman Prescod** who was once described as a 'pestilent demagogue'. Champion of the masses, agitator, owner and editor of the *Liberal* newspaper he was the first coloured member of the House of Assembly (1843–1862)[3]. Prescod's portrait is well known as it graces Barbados currency. But his last residence is also of some significance. He lived at Belfield, Black Rock, now the Nightengale Home, from 1856 until his death in 1871.

The **Nightengale Home** is also a monument to another outstanding Barbadian, **Dr. William Henry Nightengale** (1869–1948), a black Barbadian dentist who had practised in San Fernando, Trinidad, but bequeathed the property for use as the Nightengale Memorial Children's Home. It has been for a long time in poor repair, but restoration is planned. It is a solid, sound Bajan classic, two storeys on a grand arcade, with a parapet roof, a sweeping entrance staircase and mounting blocks for getting on to a horse.

Prescod's contemporary, equally radical in his own way, was **James Young Edghill**. An agitator from his teens as a reporter, he became Editor of *The West Indian* newspaper at 19, and ran it from a house on Coleridge Street, now Mottley House. He fought, like Prescod, to lower the franchise and help the poor. He started ragged schools, Industrial schools and Friendly Societies. He became a Moravian priest, and based at Calvary, he was Superintendent of the Moravian Churches in Barbados. He finally sold *The West Indian* to James Barclay and James Fraser.

Prescod's disciple was **Conrad Reeves**, son of Thomas Reeves a druggist and Phyllis Clarke, a free black woman. Beginning his career as a journalist, he became a lawyer and then the first black Chief Justice in Barbados or the British Commonwealth. His bust stands in the House of Assembly.

Sir Conrad Reeves lived at **The Eyrie**, off

The Eyrie, Community College. Perched on its own eyrie, this fascinating house spreads its wings dramatically above the college. Its outstanding cast-iron work and architecture put it among our finest treasures.
(*Felix Kerr*)

Government Hill or Two Mile Hill from 1871 when it was a small cottage, until he died in 1902. It was enlarged for him by C. J. Greenidge, builder of the Barbados Mutual and the St. Michael's Almshouse (now the Geriatric Hospital). The Eyrie is now the Fine Art Department of the Community College. The cast-iron work, ornate but delicate, is matched only by that of the Mutual Building itself.

The east side of the house, even more than the west entrance, tells us why it's called The Eyrie; it is perched on its own hill. Its arches and castellations are pure Gothic charm. The Eyrie has one of the few fish pond roofs left in Barbados. A huge copper tank on the roof, seen from the Art Studio

below, collects rain water which is led by ornate cast-iron pipes to the garden.

Sadly, The Eyrie is in an appalling state of neglect, as Government budgets have virtually ignored it for years; it is a unique national treasure in urgent need of help.

Sir Conrad Reeves was succeeded as Chief Justice by **Sir Herbert Greaves**, a most humane Judge, Attorney General and brilliant statesman. He has been described as our foremost son. Sir Herbert Greaves lived for most of his life at **Stratford Lodge** on Two Mile Hill. Originally a small, classic Bajan house on two storeys, it was enlarged to the East. On the other side of the garden was a gate to the garden of King Ja Ja who lived next door at Walmer Cottage.

Dr. Charles Duncan O'Neal entered Parliament in 1932, 50 years after Greaves. Uncle of Errol Barrow, he worked unstintingly, against terrible opposition, in the interest of the masses. O'Neal's family owned several properties in St. Lucy, and he was born in the tiny village of Nessfield, formerly a plantation, behind St. Lucy's Church. The house, much altered, is marked with a plaque, but he is, perhaps, much better commemorated in the Charles Duncan O'Neal Bridge.

One of the members of O'Neal's Democratic League was **J. A. Martineau**. It was in Martineau's House on Bay Street that the Barbados Progressive League (Barbados Labour Party) was formed on 31 March 1983. Martineau was an entrepreneur and a politician, but very much a social reformer and an unsung hero of the reforms of the 1930s. His intellectual spirit is admirably perpetuated in the new use of his house as a bookshop, The Book Place. The house itself is a classic town house of the 1860s (see Chapter VI).

The Barbados Progressive League was soon formidably led by **Grantley Adams**. Adams' story, like Barrow's, hardly needs retelling. After leading the reforms from 1937 to 1954 (introduction of full adult suffrage), Adams played a major role in the plan for the Federation of the West Indies (1958–1962). And so his house **Tyrol Cot**, on Codrington Hill, is a monument not just to a Barbadian statesman, but to one of the most important regional and commonwealth statesmen. It is also the birthplace of Sir Grantley Adams' son, Tom Adams, Prime Minister from 1976 to 1985, and described by past Canadian High Commissioner, Noble Power, as one who gave dynamic, thoughtful and effective leadership.

Tyrol Cot is equally important on its architectural merits. Built in 1854, it is a unique and perfect culmination of classical design, blended with tropical design features, born of the creativity of a fine and experienced builder, William Farnum, who also built Glendairy Prison. It is strong yet graceful, with classic proportions and arches, but perfectly adapted for both heat and hurricanes. There are many large, many interesting and many special buildings in Barbados, but few, if any, can surpass this superb building of rich history and great beauty, but now almost forgotten and in urgent need of restoration.

Barbados' leaders are not all men. Two great and wonderful daughters have died in 1988.

Daphne Joseph-Hackett taught drama at Queen's College and devoted a warm and generous life to the development of drama and dramatists in Barbados and the Caribbean. She lived for many years in the flat above the Headmistress' House at Queen's College, a classic two-storey verandahed house, probably of the early nineteenth century. It

Tyrol Cot, Spooner's Hill – fading beauty, like a classic Greek temple – rich in history.
(Henry Fraser)

was built on the site of the first St. Michael's Almshouse, later the site of the Free School established by the will of Henry Drax. The Boys' Central School was established in 1819 on the same site, many years after the disappearance of the Free School. This was upgraded in 1879 and renamed Combermere School. The entire site was taken over by Queen's College in 1943. But Queen's Park House was perhaps the real home of Daphne Joseph-Hackett, for the Queen's Park Theatre was very much *her* theatre.

On the other side of the island is a monument to **Iris Bannochie** – grand dame of Barbadian and International horticulture – botanist, gold medal winning horticulturist, environmentalist and writer.

Iris created **Andromeda Tropical Gardens**, at Bathsheba, from eight acres of rocky hillside. Her house and garden, like the legendary Greek princess Andromeda, was chained to a rock, but it explodes year round with colour and beauty, perhaps *the* garden of the Caribbean. In characteristic patriotic spirit, she has left Andromeda Gardens in the care of the Barbados National Trust, for the Nation, her beloved Barbados. The National Trust has launched an Andromeda Appeal, to upgrade and run the garden.

All these leaders include statesmen, journalists, priests, doctors, lawyers, teachers and social reformers. The last is a sportsman, yet in a sense was all of these.

In Pavilion Road, **Bank Hall**, stands the boyhood home of **Frank Maglinne Worrell.** Worrell's home, with its little verandah, was modest by the standards of Culloden Farm or St. Nicholas Abbey. Yet Worrell's home was also *across* the verandah, at Empire's famous cricket ground, where he spent much of his boyhood, watching and living his great love, cricket, from his earliest 'boy days'.

Sir Frank Worrell's glorious achievements as a great batsman, versatile bowler, accomplished diplomat, captain and leader were an inspiration to every Barbadian and every West Indian. He died in 1967, four months after Independence. In Sir Learie Constantine's words, he was the first hero of the new Nation; his home was not just Bank Hall or Barbados but the whole world.

The boyhood home of Sir Frank Worrell, Pavilion Road, Bank Hall.
(Felix Kerr)

This personal pantheon excludes many of the great names in our heritage[4]. There has been no room for the many great legislators, like Sir Charles Pitcher Clarke, great teachers like Rawle Parkinson and Bill Emtage, great journalists like Valence Gale and Clennel Wickham, scientist John R. Bovell, our father of literature Frank Collymore or artist and teacher Golde White; for the slave leaders like Bussa of whom so little is known; or for the thousands of Barbadian emigrants, from unsung Panama Canal workers to men like Thomas Chenery, editor of the *London Times*[4]. But these leaders certainly had in common 'the one thing that matters – our desire to leave the island a better place than we found it'[5].

And in looking at their homes we see the breadth and the variety of the men and women who helped to build Barbados. They all deserve to be commemorated, but some of these houses are architectural treasures as well as historic sites. In addition to marking such places with plaques one hopes to see monuments like Prescod's house, the Nightengale Home; the Adams home, Tyrol Cot; and Reeves' home, The Eyrie, restored, preserved and enjoyed as national *Treasures* for posterity.

Chapter X

Houses of Worship

St. James Parish Church.
(Felix Kerr)

Houses of worship have always been of the greatest importance in the lives of Barbadians. The oldest site of worship in Barbados is at St. James Parish Church. Early records are scanty, but it was here at Jamestown or the Hole, and hence Holetown, that the good ship 'William and John' landed with the first Afro-European settlement in 1627.

We know there was a priest in Barbados by 1628 – one Mr. Kent Lane. And, from a letter of Rev. Thomas Lane, Minister of St. Michael to Archbishop Laud, Archbishop of Canterbury, we know that by 1637 six churches had been built. The first six parishes and their churches were St. James, St. Michael, St. Peter, St. Lucy, St. Andrew and Christ Church. The remaining five were carved out of these first six. Governor Phillip Bell is usually given credit for this, but it is clear that the building of chapels of ease and the recognition of additional parishes evolved over several years, between 1639 (before Bell's arrival) and 1652 (the recognition of St. Joseph, the eleventh parish).[1]

Early churches would have been simple wooden buildings. It is believed that the first stone church at **St. James**, was built in 1660. The baptismal font is dated 1684, and the King William III bell 1696, so there must have been an impressive stone church by then.

The present church is the result of rebuilding in 1789 and 1874. It is claimed that the lower walls and part of the south porch are part of the original stone church. And if we look closely at the south porch with its two stone pillars and broad archway with ornamentation over the door, we can see a striking resemblance to the entrance of the Holetown Police Station, the original James Fort. We do not know the exact dates of either, but there is a medieval flavour to both of these structures, the two earliest and most important buildings in Holetown. They are almost certainly the earliest stone buildings in the area and parts of them must be well over 300 years old.

We know that in 1874 the nave of the church was extended to the West and the chancel was enlarged. We do not know when the quaint round tower with the spiral staircase was built, or if the squat, simple tower is much altered. But inside, the robust stone columns are unlike any of our later churches, and give St. James its unique feeling of antiquity, in spite of the handsome restoration that was recently done.

The first church of **St. Michael** was a wooden church on the site of St. Mary's and was almost

certainly, with St. James, one of the two oldest sites of worship. It was replaced by a new church, built up the street, between 1661 and 1665; this is now the Cathedral. Unlike St. James and the old church of St. Michael, it was built of stone from the start. But the story of the Cathedral is a saga of unbelievable troubles, building, repairing and rebuilding. The great barrel vaulted roof with 'but a single arch and no intermediate supports' caused the walls to bulge, and buttresses had to be built; yet the entire north wall and porch were demolished and rebuilt, in the same dramatic single span. In 1780, the great hurricane demolished the lot, and the new church was built with £10,000 raised by lottery!

This rather eclectic-looking building, a large, essentially Gothic parish church with a square tower, survives much as it would have been built in 1784–86, apart from the barrel vaulted ceiling. It is a Gothic survival, antedating the arrival of neo-Gothic in Barbados by 50 years. Its only concession to the Georgian style of the period is the delightful Caribbean Georgian detailing of the porches.

Of the parish churches only **St. George's**, demolished in 1780 and rebuilt in 1784, survived both the 1831 hurricane and the next 150 years, making it the oldest complete church. Unlike St. Michael's Cathedral, it is more of a hybrid or mixture of Georgian spaces and detailing, particularly the arched windows and doors, with Gothic crenellations and buttresses. St. George's is famous for the magnificent altar painting of the Resurrection by Benjamin West, American President of the Royal Academy of Art. The story goes that this beautiful painting was stored in a warehouse at Lower Estate because the donor, Henry Frere, fell

St. Michael's Cathedral.
(Felix Kerr)

St. Mary's Church.
(Felix Kerr)

out with the Rector. A thief entering the warehouse, noticed the eye of the centurion, and thinking it was a watchman, stabbed him in the eye!

The next step in the evolution of styles is **St Mary's Church**. St. Mary's was built in 1825, on the site of the old Churchyard, where the first St. Michael's stood. The cornerstone was laid by Bishop Coleridge soon after his arrival as the first Bishop in the West Indies in 1825, but the church was not designed by him. It is essentially a Georgian church, with its huge quoined windows and arches. Its only token concession to the Gothic style is the castellated tower. It has some particularly attractive porch windows, clearly stated Caribbean Georgian arches with jalousies, and the finest decorated church ceiling we boast.

As we noted, Bishop Coleridge arrived in 1825 and he knew how to get churches built! He was an artist and he certainly seems to have designed many of them; he built what Bajans would call 'a wash of chapels', six in three years; they all were tragically destroyed in the hurricane of 1831. But he would not be outdone, and he started all over again at once. In the next ten years he built ten chapels of ease and six chapel schools.

They were called 'chapels of ease' because they were easier to get to than the parish churches. They were built for the convenience of parishioners living far from the parish church. **St. Paul's** was the favourite of the Bishop. Like the others, it was pure Gothic – simple but pure Gothic, through and through. Bishop Coleridge came to Barbados when the Gothic Revival or Neo-Gothic style was beginning to capture the British imagination, and all of his chapels had steep gable roofs, parapet walls, slender pinnacles or finials at the corners and elsewhere, buttresses for both strength and ornament, pointed arches and lancet windows. Nearby, at Bay Mansion, is what is thought to be the Bishop's design of a Gothic gazebo, and behind the rectory of St. Paul's is another gazebo, octagonal in shape but in Gothic style.

As the late architect Barbara Hill said, the Coleridge Chapels were not great architecture, but they were unique[2]. They evolved as a distinct style of church architecture, a local Barbadian vernacular with its own charm and elegance, and a characteristic simplicity. They set the pattern for local church building for the next 100 years and more.

Most of the parish churches were destroyed in the 1831 hurricane and had to be rebuilt; they, too, emerged as simple but classic Gothic churches. **St. John's** is, perhaps, the purest and the most beautiful. All the essentials of 'the true church architecture', the Gothic, harmoniously combined and anchored to Hackleton's Cliff so firmly in its design that it looks almost as if it was carved from the rock. St. John's is famous for its magnificent view of the

St. John's Parish Church.
(Willie Alleyne)

Tomb of Ferdinando Paleologus,
St. John's Churchyard.
(Felix Kerr)

63 Houses of Worship

Scotland District, of Newcastle and Below-the-Cliff; for the old Sundial and the panorama from the cliffs of Consett Point in the East across the venerable tombs of ancient planters to the beautiful Bathsheba coast and Pico Teneriffe in the North; for the ghostly sepulchres of the ancient churchyard, especially the tomb of Ferdinando Paleologus, last of the family of ancient Greek Emperors of Constantinople, planter and churchwarden of St. John in 1655, the year Penn and Venables captured Jamaica from the Spanish.

St. John's is also famous for the richly carved pulpit of six woods, ebony, locust, Barbados mahogany, manchineel and imported oak and pine. It is famous for the exquisite sculpture by Sir Richard Westmacott, sculptor of the statue of Nelson in Trafalgar Square; and for some of the most ancient memorial tablets in the whole island, paving the church. The delicate carvings, the fluted columns and much of the woodwork is now undergoing major restoration work. St. John's desperately needs help; it is a treasure in search of benefactors.

Although there are nearly 50 historic Anglican churches, that is not the whole story. The Moravians came to Barbados in 1765 to bring the Gospel to the slaves. By 1799, they could build an ambitious church at **Sharon**, in the style of Eastern Germany with its low tower and elegant bellcote or lantern. Mount Tabor in St. John, and Calvary in the Roebuck came later. Sharon was badly damaged in 1831 and rebuilt. Today it is unaltered, except for serious decay, and, at the time of editing, it is having its roof replaced. It is a dramatic structure and a monument to our most heroic Christian movement. It is a national treasure, and like St. John's, in desperate need of help.

The Methodists, like the Moravians, came with a mission for the slaves. Their first meeting house in James Street, vandalised in 1823 by a mob, is the site of the James Street Methodist Church, essentially Georgian, with a Palladian porch and a fine rose window. Their lesser churches cover a wide gamut, from the 'wedding cake' effect of Providence in Christ Church to the Caribbean Georgian gem at Shrewsbury near Sam Lord's Castle. And the elegant Dalkeith Hill Church made history with the first installation of electricity in a church in Barbados.

It is said that in Dominica there is a river for every day in the year. I think that Barbados has a church for every day in the year, and quite a few left over!

Spiral staircase, St. John's Church.
(Willie Alleyne)

Sharon Moravian Church.
(G. W. Lennox)

Stained glass altar windows, All Saints Church, St. Peter.
(Willie Alleyne)

St. Peter's Church.
(Felix Kerr)

From the quaint St. Margaret's in St. John, built from the old sugar boiling house, to the elegant St. Patrick's Cathedral, completed in 1848; from the ancient mortuary chapel of Joe's River, to the ultra modern churches of St. Leonard's and St. Dominic's. St. Patrick's Cathedral has the finest reredos, and a dramatic hammer-beam ceiling. All Saints has the finest stained glass and a beautiful hammer-beam ceiling. Holy Cross and St. Ann's have the only spires.

For church buffs, Barbados is a treasure trove. For Christians, churches are houses of worship and prayer. But even for people of other religious communions, or people with none, these buildings evoke spiritual responses; they encapsulate the hopes and the prayers, the joys and the sorrows, the pride in the craft and the inspiration of a place of beauty and reverence.

These unique stone churches have sheltered us in storms and comforted us in times of need. Many, like St. John's, a favourite tourist site famous the world over, desperately need our help now. They are truly *Treasures of Barbados*.

Chapter XI

Historic Hotels

Bush Hill House, the Garrison, where George Washington stayed in 1751, on his only trip ever outside the United States.
(Henry Fraser)

Today Barbados has over 100 hotels, including glittering resorts like the Grand Barbados, built on the site of the old Naval Dockyard and the Engineers' Pier; for many years it was the old Aquatic Club. At the end of the pier, the Aquatic Club bar is now the Schooner Restaurant, another evocative memory of Bajan history, when schooners plied the West Coast.

But how and where did Bajan hotels begin? Not with elegant resorts but with simple hostelries or lodging houses, chiefly kept by free 'ladies of colour'.[1]

Rachel Pringle Polgreen was Barbados' first well-known hotelier. A famous Thomas Rowlandson aquatint of 1796 shows a mature Rachel with the two traditional characteristics of a well-to-do West Indian matron – ostentatious jewelry and enormous obesity. She is also shown in youthful beauty, with her coarse and evil father, who clearly suffered from elephantiasis, which most people called Barbados leg, but which Barbadians call Guyana leg. At the top right of the picture is represented her lover and benefactor, Captain or Lieutenant Thomas Pringle.

Rachel's hotel has long since gone, in the fire of 1821, but it was somewhere in Canary Street, now St. George Street, on or near the site of S. P. Musson. Rachel's main claim to fame was the adroit way she dealt with the delinquent Prince William Henry on one of his visits in 1786 or 1789. He and his boon companions visited her Navy Hotel, wrecked the joint and then capsized Rachel's chair. She simply sent, next morning, an itemized bill for £700 to the Prince on board his ship at anchor in Carlisle Bay. He paid at once. She renamed her establishment the Royal Navy Hotel in memory of the incident and her royal patronage. She never looked back, and when she died, she owned most of Canary Street.

Nancy Clarke, a real virago, took over the Royal Navy, but she got stiff competition from the famous **Betsy Austin** at the Clarence Hotel on Macgregor Street, now Dominoes restaurant and the Food Basket. Betsy was a massively built battleaxe, who drank like a fish, swore like a trooper and had exorbitant rates.

In 1751, the young George Washington brought his brother, Lawrence, here for his health, so Barbados may have been known, even then, for its healthy atmosphere although the Washingtons did have close connections here. But on medical advice the Washington brothers found lodgings 'in

the country', settling on 'Captain Crofton's' which is now established to be **Bush Hill House** at the Garrison.²

By the end of the nineteenth century, sea-bathing was the 'in' thing and hotels were opened at Bathsheba, the Crane and Hastings. The Beachmount opened at Bathsheba in 1885, but was burnt down in 1938. The first **Marine Hotel** at Hastings began in 1878, but was replaced in 1887 by George Whitfield with the present massive structure, at a cost of £15,000. The new Marine Hotel had 200 rooms and was *the* Hotel in this part of the world for 75 years. Its ornate cast-iron balustrades, sweeping verandahs and huge ballroom were famous. In 1972, the Barbados Government bought it from the Goddard Group of Companies for use as offices. As Marine House it now accommodates several ministries.

In July 1887, the **Crane Hotel** opened its doors; it was a lavish old seaside house called Marine Villa. It was opened by D. M. Simpson when the new Railway made the Crane Coast accessible to anyone from Bridgetown. He added the south wing, built like a fortress, and in 1921 another owner, J. D. Lamming, added the ballroom. In 1967, Julian Masters bought it, added the French chateau turrets, and brought it to today's luxurious elegance, with Roman style pool and dramatic masterpieces of modern Italian sculpture. But the Crane's magic is the magnificent setting, as the hotel sits like a sculpture on the Crane Cliff, overlooking the famous Crane Beach and the Atlantic rollers.

Of the same period are the Seaview and the

The Marine Hotel, now Marine House.
(Felix Kerr)

The Crane Beach Hotel.
(Felix Kerr)

Ocean View at Hastings, and the Atlantis at Trent Bay, Bathsheba, followed by the Kingsley Club at Cattlewash. **The Atlantis** was started by Miss Emmeline McConney, and the train dropped you right below its breezy verandah. Today the Atlantis' Sunday lunch and Miss Enid Maxwell, proprietress, are a Bajan institution.

Over at Cattlewash is another traditional and very comfortable seaside inn – **Kingsley Club** – more of a classic, sprawling seaside house and as famous for its fish food as for the invigorating Bathsheba air.

But the longest continuously running hotel of all must be the **Ocean View**. It started as the Family Hotel in the 1890s, run by Mrs. Henrietta Marson in Lucas Street. Mrs. Marson, with real vision, moved to Hastings around 1900, by now the booming hotel district. She bought out the Little Chateau Hotel next door, and by her death in 1909, had renamed her establishment the Ocean View. Her daughters, Amy and May, ran it for another 20 years, and their nephew, Victor Marson, bought it on their death. Victor really *made* the Ocean View, extending it twice in traditional nineteenth century Bajan style, with parapets, jalousied window fixtures and dramatic oriel windows on the sea, and a verandah with Demerara windows which overlooks the Caribbean. He built the Xanadu in 1940 – the dance floor and night club.

Today the Marson gourmet tradition is perpetuated in the dining room and the elegant, historic Crystal Room. Here, over the banqueting table, are two of the famous three crystal chandeliers, the third one being at Sam Lord's. They crashed to the floor a few years ago, but have been painstakingly restored by the present owner and manager, John Chandler.

Nearby, within the Garrison precincts, is the **Seaview Hotel**, where major restoration has just been completed. The Seaview was a canteen from the earliest Garrison days, and known as Sheriff's House until the 1840s. It was opened as the Seaview Hotel by a Mrs. Piggott in 1887, but it had a checkered history, until today's renaissance in the hands of Bobby Weatherhead.

It consists of two adjacent houses, but the main building is the one of major architectural interest. It is lavishly built, largely of English ballast bricks, on a long, narrow plan, with a central hallway and double balconies, exactly like the single houses of Charleston. Its ornate cast-iron balconies are reminiscent of New Orleans and are of North American design, but the massive door-hinges used throughout resemble the eighteenth century fittings used in the British Garrison buildings. The plaster mouldings are typically Georgian, as is the impeccably restored panelling of the elegant Virginian Restaurant next door.

Unlike these ancient hostelries, all around 100 years old, two modern hotels have been converted from ancient buildings, The Island Inn and Sam Lord's Castle, now Marriotts Resort.

The Island Inn occupies the old Garrison's Rum Store, built about 1804 as part of the British Navy's Dockyard. Its three wings around a central courtyard are the original format of the rum store. It was opened as the 'Aquatic Court Guest House' by a Miss Violet Watson in 1936, and later became

Ocean View Hotel, Hastings.
(Felix Kerr)

The Island Inn. It has just been lavishly restored by Frank and Peter Odle, emphasizing its historic fabric of rubble stone, brick and wooden balconies.

Sam Lord's Castle was built in 1820; it is a fashionable Regency mansion of the time with a touch of trendy neo-Gothic ornament in the battlements, to set the tone for the swashbuckling, lavish life-style of the amoral Regency Rascal, Samuel Hall Lord. With its magnificent interiors, especially the exceptionally fine plaster ceilings by Charles Rutter, it is one of the most important historic buildings in the Western hemisphere. Its decorative recessed panel became an essential motif in Barbadian house design for 150 years, and is enjoying a new wave of popularity today.

Sam Lord's became a hotel in 1942, designed and developed by Victor Marson. He added the matching wings, and laid out the gardens and fountains. Today it is part of a major Marriott luxury resort, but in 1942 it was ahead of its time. It pioneered, in Barbados, what has become a crucial metamorphosis of many historic houses in Europe, into luxury hotels, like the paradores of Spain and the stately homes of Britain. Yet the Sam Lord's example remains unique in Barbados.

Conversion of ancient houses and castles into hotels began in Europe with the Spanish paradores in the 1930s. Today Spain is a model of history working for tourism, with its network of castles and historic buildings catering for millions of visitors. In Britain too, hundreds of stately homes are now stately hotels. From Florida to Australia, historic hotels are in fashion. Even Jamaica, with the magical scenery of Port Antonio and the exotic delights of rafting on the Rio Grande, has a new Gothic pile, Trident Castle, to provide the historic ambience that is the 'in thing' in tourism today. Nearer to home, tourism in Nevis, St. Kitts and Antigua places great value on luxury hotels adapted from historic sites like Golden Rock Hotel's amazing barrel-vaulted barn in Nevis, St. Kitt's exotic Lemon Grove Great House Hotel, and Admiral's Inn at Nelson's Dockyard or English Harbour in Antigua.

The restoration of buildings like the Seaview and the Island Inn represents a turning point for

Seaview Hotel, the Garrison.
(Felix Kerr)

Sam Lord's Castle.
(Willie Alleyne)

Barbados, because the chrome and glass tower on the beach is no longer the prime focus; character and tradition and heritage have become fashionable, as the post-modernist and traditional styles springing up around the world are showing. Perhaps the grand old lady, the Marine (now Marine House), should be part of the renaissance. In any developed country, it would long since have been restored. Are we ready to make other historic buildings work for us in this way, as they are crying out to do? We have ample evidence that our historic hotels are not just beautiful buildings, but major assets for tourism. They are truly *Treasures of Barbados*.

Chapter XII

Parliament

In 1989 Barbados commemorated the triquintennial of Parliament – 350 years since the most undemocratic origins of Parliament in 1639. That first Assembly was really a sham, with burgesses probably chosen by the Governor himself, Henry Hawley. Hawley was clearly a rogue and a rascal. And for the next 200 years, until 1838, Parliament remained the antithesis of democracy, because it was elected by little more than 1 per cent of the people. But the story of Parliament, both the context of its early history and its evolution into the effective instrument of democracy we now take for granted, is crucial for us to understand where we are today.

The Early Days. Barbados was claimed for England in the reign of James I, in 1625, when the good ship 'Olive' or 'Olive Blossom' landed first at Holetown and then at Indian River, now a mere gutter under the Spring Garden Highway. For many years this date was thought to be 1605 and in 1905 the Tercentenary was celebrated with great pomp and ceremony, and monuments were erected at Holetown and Indian River.

In 1627, **Captain John Powell** established the first settlement, financed by a London merchant, Sir William Courteen. Powell brought planters, servants and ten Africans. He also went to Guyana and brought back both plants (like cassava) and Amerindians to teach the settlers local agricultural methods. But King Charles I then granted the Earl of Carlisle a charter, literally giving him Barbados as Lord Proprietor, and giving him power to make laws for Barbados. Carlisle delegated his authority to **Charles Wolverston** as Governor, and then to successive Governors. Wolverston overthrew the Courteen Governor, John Powell, and on 4 September 1628 he and 12 of his cronies met and issued a proclamation that, among other things, 'it shall be lawful for any two or more of them to *execute* and punish all such offenders as shall presume to break His Majesty's peace...'

Those were days of rough and ready justice, greed and opportunism. Wolverston was kidnapped by Powell's brother Henry Powell, and shipped home, and John Powell was reinstated. Then **Captain Henry Hawley** was sent out by Carlisle; he kidnapped John Powell and sent him packing too! **Sir William Tufton**, who arrived in 1629, was the next official Governor, and his claim to fame is a lasting one. He divided the island into six parishes, according to the six churches built by then, each

Roebuck Street, where the early House of Assembly met for many years.
(*Felix Kerr*)

with an elected vestry, the English style parish council. Hawley got rid of him in 1630 by execution on a charge of treason, and took his place.

But Hawley discovered, while in England in 1639, that the Earl of Carlisle was about to replace him because of all kinds of unscrupulous behaviour. Until then, he had ruled with a hand-picked Council, but it seems that he now distributed land and offices and 'arranged' an election of burgesses who would sit with his Council. In other words, he 'settled a Parliament' but almost certainly a Parliament of his choice, by ingratiating himself with enough planters that he could depend on. This Parliament consisted of himself as Governor, his nominated council and the elected or so-called elected House of Burgesses or House of Assembly. It was conceived by lust for power and born of expediency! Ironically, while a Parliament of sorts, loosely modelled on Westminster, was coming about in Barbados, there was no Parliament at all in England! Charles I had dissolved it in 1629 and ruled without it for 11 autocratic years until 1640, but friction worsened and civil war broke out between King and Parliament in 1642.

The Council appears to have met at the Governor's Residence, first a house in Bay Street, then a house in Hall's Road; later Holborn in Fontabelle and then, from 1703, Great Pilgrim House – today's Government House.

The **first House of Assembly** was a building known as the 'Sessions House'. It may have been built by Hawley originally for his Courts of Law. It stood in the Marlhill, close to what is now Spry Street and close to the site of the Central Bank. (It is now marked by a monument unveiled on 25 June 1989.) But by 1653 or earlier, the Assembly shifted to the State House in Cheapside; this could have been anywhere along Broad Street, as all of our main street was then called Cheapside. For the next 100 years, the Assembly moved from pillar to post, borrowing or renting houses all over Bridgetown, from the house of Edward Preston to that of William Wilson; from the tavern of Judith Sparrow, to the tavern of Paul Gwynn; from the Roebuck Tavern in Roebuck Street to the Governor's residence at Holborn, Fontabelle, demolished thirty years ago to make way for oil bunkers. But the favourite meeting place was the **Roebuck Tavern**, somewhere in Roebuck Street. Actually this belonged to none other than the notorious founder of the Assembly, Henry Hawley himself. In fact, in 1677 Hawley fell down the stairs of his own tavern and died of internal injuries caused by broken ribs. It is unclear whether his fall was due to infirmity – he was 80 years old – or to too free an indulgence in rumbullion (the original name for rum, coined in Barbados in those early days). He might well have been the best customer of his own tavern.[1] It is not surprising that Governor Atkins, attending a meeting at Gwynn's tavern in 1674, said: 'I must confess I am a little astonished to see so honourable an Assembly to meet in a place so

considerable as the island is, and have no house to receive us but a public tavern'[1].

The Charter of Barbados. When the Civil War ended with the execution of Charles I in 1649, Carlisle ceased to be Lord Proprietor and the English Parliament moved to take control of the colony, which was openly supporting the Royalist cause. The new Governor, **Francis Lord Willoughby** of Parham, was an ardent Royalist and his first act was to proclaim the accession of Charles II and pass an act acknowledging his sovereignty of Barbados! Many Royalist supporters had also fled to Barbados. Cromwell therefore appointed Admiral Sir George Ayscue to subdue the recalcitrant colonists, by force if need be. This was a line of argument that Cromwell now embraced freely and had just used in his monstrous massacre of the Irish at Drogheda. There he personally ordered no life to be spared, and slaughtered 2000 Irish in one night.

Colonel Alleyne and several other anti-Royalist planters went to England and apprised Cromwell's Council of State of the situation in Barbados. Cromwell's Parliament placed an embargo on all trade with the Dutch, an action designed to 'mortify and oppress the Barbadians'. The Barbados Parliament responded with a declaration of 18 February 1651, in which Lord Willoughby and the legislature of the island defied the English Parliament[2]. They were soon put to the test. Ayscue's fleet of seven ships and varying estimates of 2000 to 3000 men blockaded Barbados, and eventually invaded at Speightstown in December of 1651. Colonel Alleyne was killed by a musket ball in the landing but the invaders won the day and burnt the town.

Willoughby capitulated soon afterwards, and at the Mermaid Tavern in Oistins on 17 January 1652, the **Charter of Barbados** or **Articles of Agreement** were signed. There were 23 Articles and the most important perhaps were: liberty of religious conscience, no taxation without consent of Parliament (more than a century before the North Americans protested against taxation without representation), free trade with all nations trading with England, and Government by a Governor, a Council chosen by the Governor and an Assembly elected by Freeholders. But one of the best is Article 20: '. . . a strict law be made against all such persons . . . that be guilty of any reviling speeches of what nature soever, by remembering or raveling into former differences, and reproaching any man with the cause he has formerly defended'. In other words, there must be no victimisation for party politics!

In 1660 the Republican rule of Oliver Cromwell came to an end in Britain and the monarchy was restored in the person of King Charles II, one of the playboys of all time. He led a promiscuous and decadent life style, remembered for his generosity to his loyal subjects, especially his many mistresses and their many children, and is even remembered in the name of a rather decadent looking breed of dog, the foppish looking King Charles spaniel!

Charles purchased the proprietorship from the Earl of Carlisle's heirs in 1663, and was invested with the patent rights of the now thriving Barbados. The claims of Carlisle's heirs were paid out with revenues collected. The continued collection of the 4½ per cent export tax on island produce (until 1834) was an irritating political grievance.

Meanwhile, the General Assembly was limited to one year by an act of 1660, and the franchise was rigidly restricted to adult, white, Christian males, natural born or naturalised British subjects, owning ten or more acres of land or a house with a taxable value of £10 – perhaps 1 per cent of the total population and a mere 5 per cent of the white population. In other words, in those early days not only were slaves excluded from citizenship, but so were all women, all Jews, all free coloureds and free blacks, all indentured whites and free poor whites, and all those of modest income, most of the free white artisans. Other legal and social restrictions of civil rights were enforced on religious grounds on Jews, Quakers and Catholics, and of course, on all women, who were very much third class citizens, could not own property and were apparently considered too mentally incompetent to vote until 1943!

For the next 150 years, Parliament concerned itself mainly with three issues: trade and taxation, maintaining the stability and status quo of the plantation/slave society, and the defences of the island. From the middle of the seventeenth century, a series of forts were built along the accessible West Coast (see Chapter IV).

An important Parliamentary contribution in the eighteenth century was made by Sir John Gay Alleyne of Nicholas, humanitarian and founder of the Alleyne School, and Speaker of the House for

thirty years. He achieved the basic three privileges of members: freedom from arrest, freedom of speech and freedom of access at all times to the King's representative. It was not always so; when the Speaker John Jennings challenged the despotic Governor Lord Willoughby, he was arrested, disgraced by being made to ride bareback, facing backwards on an ass, flogged and imprisoned!

Meanwhile, where was the legislature sitting? In 1663, the Crown had agreed that the 4½ per cent export tax on island produce should meet expenses of government, including the building of a Sessions House. And so, one Assembly after another refused to vote money for a Sessions House. Meetings continued in taverns until 1700 when a State House was built in the grounds of James Fort, now the old Carlisle Bond of DaCostas. But in 1704 it was urgently converted into a Common Jail, and the Assembly and Council were back to square one! The Assembly met again at Edward Arnell's House on Egginton's Green, now Trafalgar Square and the Council at the Governor's house.

Finally, an Act of 1725 authorized a **Town Hall** and **Jail** at a cost of £600. It was completed in 1732 and first used on 8 May 1733, although our legislators often met in taverns as well, perhaps for obvious reasons! When they did meet in the Town Hall, they brought their liquor with them. Dr. George Pinckard, a visiting English physician in 1796, described a sitting of the house: 'One part of the proceedings, however, we thought to be strictly in the order of the day ... It was excessively warm, and we were sadly parching with thirst when two persons suddenly appeared with a large bowl and a two quart glass filled with punch and sangaree. These were presented to "Mr. Speaker", who after dipping deep into the bowl, passed it among members ... nor was the audience forgotten'.

The Emancipation of Parliament. The nineteenth century brought, at last, some change in the old order. There was a ground swell of anti-slavery feeling in Britain, leading to the British abolition of the slave trade in 1807. The Moravian and Methodist Missions brought Christianity to the slaves. The rebellion of 1816, now called by some the 'Bussa revolt' after Bussa, the slave leader from Bayley's Plantation; the law known as the 'Brown Privilege Bill' of 1831, freeing up the 'restraints on the free coloured and free black Barbadians', and the arrival of the first bishop, William Hart Coleridge, bringing a programme of churches, chapels and schools for the christianisation of the whole community, all helped to prepare the society for the inevitable change in the old order.

But the legislature dug their heels in when it came to the question of amelioration and emancipation, and it virtually had to be imposed by the mother country. First, on 1 August 1834, came four years of Apprenticeship. Finally came the Act passed in the 'New Town Hall' at Codd's House (demolished in 1985), and with great celebration on the part of the black population, on 1 August 1838, came Emancipation. Every man, woman and child in Barbados became fully free. When Parliament opened on 31 October 1838, Governor MacGregor urged the legislature to provide for a Hospital and Lunatic Asylum, savings banks, and furtherance of education and religious instruction, while the Secretary of State for the Colonies called for poor relief services and new labour laws.

But slavery had left Barbados racially bigoted, and as rigidly class-conscious a society as Victorian England. Control of land, commerce, the professions and the civil service was unchanged. The new order of 1838 was defined in simple black and white – white capital and black labour. The reaction of the legislature to the social needs of the country was described in these words: 'The planters are blind ... deplorably blind, ... and we who were considered their determined enemies must see for them, think for them, and prevent them from ruining themselves'. These were the words of Samuel Jackman Prescod, a Barbadian of mixed race who was the prime political figure after emancipation, the people's hero and undoubtedly Barbadian of the nineteenth century (see Chapter IX).

Prescod became the first coloured man to be elected to the House when Bridgetown was made a separate constituency in 1843. As leader of the Liberal Party, he fought on every front to protect the civil rights of the poor and weak, for freedom of movement in the Caribbean, and especially for electoral reform and the lowering of the franchise qualification. When Prescod was elected to the House, there were only 1100 voters in the whole country, 900 white and 200 black or coloured. But as leader of the Liberal Party, he eventually drew his support from all sections of the community. His was the first Rainbow Coalition, the first vision of the kind of a colour-blind, unbigoted Barbados which we strive for today. Prescod was a pioneer in

every way and at every stage. He proved a reconciling influence in Barbados in spite of his assault on privilege, and has been an inspiration to his country ever since.

Education was to prove the 'Barbadian way' of advancement socially and politically. Indeed, at a time when Britain was still exploiting child labour Barbados passed its first bill for public funding of education, to help the Boys' Central School, a decade ahead of the British. By the Education Act of 1850, there was an Education Committee, and an Inspector of Schools. The Education Commission headed by Bishop Mitchinson led to the **1878 Act** which abolished aid to schools with racial admission policies. This Act was the foundation of Barbados' education system for the next 100 years, its reputed 98 per cent literacy rate and its commitment to education. By 1895, 12 per cent of revenue was spent on education, and by 1930, 16 per cent – one of the highest in the world!

Meanwhile, Parliament continued to play a game of musical chairs. The New Town Hall at Codd's House, where Emancipation was made law in 1838, proved too small, and the Assembly and Legislature returned to the **Old Town Hall**, officially named the **Law Courts** in 1958. Codd's House, next door to the Synagogue, was the home of the Waterworks Department until 1972, but was demolished without notice and in spite of public protests, in 1985.

The Public Buildings Erection Committee first met in January 1857. A massive fire destroyed much of upper Bridgetown in 1860, and Government acquired all of the New Burnt District in and around Trafalgar Square for the new buildings. Peter Paterson's Gothic plans of 1857 for the Parliament buildings were finally modified by John Bourne, Superintendent of Public Works, and the west wing and east wing were erected between June 1870 and April 1874, for a little over £25,000. However, ten years later, the massive clock-tower in the east wing started to sink; it had to be taken down and the clock moved to the South Tower in the west wing.

Soon after the Assembly's installation in its new home, the complacency of the country was shaken by the **Confederation Riots of 1876**. The brilliant, cantankerous and courageous, some might say fool-hardy Governor, John Pope Hennessy, attempted to bring about the Colonial Office plan for a federation of Barbados and the Windward Islands – a plan in which Barbados would have to abandon its elected Assembly. The hero of the day was Conrad Reeves, then Solicitor General and leading spokesman for the Assembly's position. Reeves also succeeded in lowering the franchise qualification in 1884 to freeholders of £5 annual value. But the numbers of voters only doubled to 2500 in 1887, giving the vote to some of the middle class clerks, teachers and overseers. This followed the similar British Reform Act of 1867, doubling their voters to 2.9 million, but only 8 per cent of their population.

Little real change came until the emergence of O'Neal and the radical or progressive black middle class with the merchant, Chrissie Brathwaite and the lawyers, Grantley Adams, Erskine Ward, H. A. Vaughan and J. E. T. Brancker. Dr. Charles Duncan O'Neal was elected to the House in 1932. Founder and leader of the Democratic League, he began to educate and mobilize the masses towards major social change.

Three days of rioting in July 1937 finally accelerated political change. Adams put the workers' case to the Moyne Commission at Queen's Park House. The rise of the Barbados Workers' Union with Adams as President General, and of the Progressive League with Adams as President, led the way to votes for women in 1943, 15 years after Britain, and to the Bushe Experiment of 1946 for calling on the leader of the Majority group in the House of Assembly to select the four Assembly Members for the Executive Committee. Full adult suffrage came in 1950, just 20 years after Britain. It is of some interest to note that these changes were passed in the Legislative Council only by the casting vote of the aged, 85-year-old President, Sir John Hutson, Medical Practitioner, who lived at Harmony Hall, now Solidarity House and the home of the Barbados Workers' Union.

Ministerial government with Adams as Premier came in 1954, and the Cabinet system in 1958. But the Federal Experiment removed Adams from the scene in 1958, and the Democratic Labour Party came to power in 1961 with Errol Barrow as Premier. In 1964, the Legislative Council became the Senate. It was always known as the Upper House, although it had less powers than the Assembly, and less ritual, and each house referred over the years to the other as 'the other place'!

In 1966, Barbados proceeded to Independence, with Errol Barrow as first Prime Minister. Sir Winston Scott became the first Barbadian-born Governor-General. The Governor-General literally

74 Treasures of Barbados

The Public Buildings, now Parliament Buildings, at Independence. Note the date palm tree, since collapsed.
(Felix Kerr)

starts and ends the game. He starts the ball rolling with the formal opening of Parliament, and he signs and seals all Acts, when passed by both houses. Sir Winston Scott was the last to wear the elaborate Windsor Uniform and cocked hat of the colonial governors.

In 1971, single member constituencies were introduced, and in 1981 the number of constituencies was increased from 24 to 27. Today there are rumblings of yet one more!

Parliament Today. 1989 marked the triquintennial of the Assembly of Barbados. Today's Parliament is very different from that of 1639. The feudal system of England which lasted virtually until this century, was, not surprisingly, translated into the plantation oligarchy of Barbados, excluding Jews, Catholics, women, the indentured, the enslaved, the poor and most of the middle class from true participation. Barbados' gradual transformation into a free and relatively fair, if imperfect, society is the envy of many, but the spirit of democracy operates within meaningful traditions and ceremonials.

The mace, for example, is a most eloquent symbol. It symbolized first the royal authority, as it was carried by the King's Serjeant at Arms, from the days of Edward I. But it gradually became the corporate symbol of the power of the House, until by the end of the seventeenth century it was such an integral part of the House of Commons that without it the House was not properly constituted, hence its place when Parliament is sitting. Likewise the original mace was a lethal weapon; if anyone resisted the authority of the Serjeant at Arms, he could reverse his mace and knock down the rebel with the flanged end. When the Serjeant no longer needed to use the mace as a weapon, the warhead grew smaller and the end of the handgrip got larger to bear the Royal Arms, embossed with orb and cross. From a deadly weapon it became a magnificent gilded work of art but still a symbol of authority. The mace in use today was acquired in 1812, when John Beckles of Beckles Road (and the Bay Mansion) fame was Speaker, and Sir George Beckwith of Beckwith Place fame was Governor. It weighs almost 12 lb, and is four feet four inches long. The Jamaican mace is an even more amazing instrument, five and a half feet long!

The Speaker's chair is not old, but equally symbolic, as the Speaker is the public or official voice of Parliament. The old Speaker's chair, a modest affair, was replaced by the present magnificent chair, a gift from the Government of India.

Many other features of the Houses of Parliament are finely crafted relics of a long period in history; for example the rich stained glass portraits of Kings and Queens in the House of Assembly, the Gothic style or neo-Gothic design in the lofty ceilings and arches, the intricate details of the coral stone sculpture.

The story of 200 years of Speakers of the House is displayed in the stained glass coats of arms around the Senate Chamber, made from copies prepared by one Jeb Clarke for 1 pound 5 shillings. Each represents a Speaker preoccupied with democracy and civic rights as he saw it in his day and age.

Of great importance is the impact of the whole

Stained glass window of Queen Victoria.
(Felix Kerr)

Parliament Buildings, recently restored, across the water of the inner basin.
(Felix Kerr)

on the public and private consciousness of Barbadians. When television cameras take us into the House for a budget debate, we are exercising our democratic rights to participate at a certain level for if we do not like what we see happening, we can change it. When our Governor-General gives the throne speech, we recognize our long but successful evolution from colonial subjects to free nation. When the Queen visits, we recall the links we share, through history, language and culture, with the millions from our brotherhood of friendly nations. And there is no doubt that part of our respect for laws and for the institution comes from the authenticity and authority of the building.

Barbadians are *churchy* people, and the great stone churches and the small stone chapels of Bimshire are etched in our souls from childhood. They symbolize both God and good, authority and benevolence, faith and love for God and love and charity for man, and the choice of a nineteenth century neo-Gothic style for our Public Buildings, with its unique Barbadian detailing and flavour, was a profound and fortunate choice.

The order and beauty of these Gothic arcades and richly carved Bajan coral stone elicit admiration. The huge entrance gates and long flight of stairs command a certain awe and respect; thus the task of the legislator is imbued with importance. More, perhaps, than any other buildings in Barbados, I suspect, the Public Buildings, recently renamed the Parliament Buildings, exercise a powerful effect on us and the way in which we regard the functions carried out within the building. In an age of irreverence, increasing moral ambivalence and confusion, and occasional hints of anarchy, it is of the greatest importance to retain the visual symbols of stability, authority and emotional values, and in the words of our national anthem, that 'pride that binds our hearts from coast to coast – the pride of Nationhood'. Our Parliament Buildings are all of these. They are truly *Treasures of Barbados*.

Chapter XIII

Finale

Treasures of Barbados – Past, Present and Future

The old Spirit Bond. A beautiful brick building with many of the finest features of early nineteenth century warehouse buildings.
(Felix Kerr)

Nowhere in Barbados is the juxtaposition of past, present and future more striking than in the centre of Bridgetown. Right in the midst of the hustle and bustle of the busy city is an oasis on the waterfront, where an ancient sugar bonding warehouse is now an elegant restaurant, The Waterfront Cafe. Where men sweated for the sugar industry, cooks and waiters now cater for today's economy, hospitality and tourism. And across the Careenage, now a marina, is a tapestry of the city's history.

Where balconied warehouses once stood, only one is left – the old Spirit Bond, built of brick, an abandoned relic of 200 years ago; the modern buildings of the 1960s are alongside – the Royal Bank of Canada's austere front concealing its elegant Renaissance facade of 1900 and next door the Women's Self Help, last of the old Broad Street shops. This stands as a welcome at the entrance to the town, and is courteously watched over by the most famous statue in the West Indies, Nelson, hero of the Napoleonic Wars and symbol of courage and leadership. Behind him are the Public Buildings – the West Wing, its exterior cleaned for the celebration of Parliament's 350th anniversary, and soon to be restored in full to its pristine Gothic glory of the last century. A beautiful building, now in search of a meaningful function. To the right are the Fountain Gardens, and beyond, the symbols of the 1960s and the 1980s – the Treasury Building, a practical modern block, upstaged by the monolithic, modernist monument to Mammon – our new Central Bank, built for the future.

Here in one sweep of the camera is seen a microcosm of Bridgetown's history. But how much more have we lost by blindly replacing the quaint and out-of-fashion with the crass but up-to-date?

We lost the superb Holborn House in Fontabelle, with its lovely arcades and battlements – the first official Government House – to make room for oil bunkers. We lost the magnificent Farley Hill, by fire, and dozens of great houses, like Seawell, Wildey and Turners Hall, by fire or bulldozer. We lost the Ice House, the Royal Bank facade, Codd's House (site of the House of Assembly, 1837–1848) and many city buildings in the name of progress. Whole streets have gone, like Swan Street and half of Roebuck Street. We have lost treasures in the old suburbs, like Friendly Hall off Whitepark Road in the city, demolished in 1970; the original Ursuline School building, demolished in 1989; and both Rosemounts, in Deacons Road in 1980, and Roebuck Street in 1988.

Government House – the finest survivor from the eighteenth century, with the first elegant bow front (emulated at Farley Hill, Bay Mansion, Villa Nova and Bentley), and elegant plaster ceilings.
(Felix Kerr)

South Point Lighthouse – an early metal masterpiece.
(Felix Kerr)

Morgan Lewis Sugar Windmill (Barbados National Trust).
(Henry Fraser)

What is the present position? To the danger of destruction has been added that of decay which is threatening many buildings: the tragic Marshall Hall on Hincks Street, seemingly abandoned by successive governments to decay, but, eminently restorable as the huge theatre it once was, as a National Art Gallery or a shopping mall; the old Vestry Hall and Town Hall when E. D. Mottley was Mayor of Bridgetown: the Old Spirit Bond which refuses to fall down; the Empire Theatre, waiting a lifetime to be used again; the Masonic Hall by the Cathedral, still in use but down at heel; Medford and Ashby's elegant Victorian pile and others on Roebuck Street, Suttle Street and Bay Street; the Exchange, one of the many properties of the wealthy, nineteenth century black merchant and planter London Bourne[1]; and outside of Bridgetown the tragic ruins of the Pavilion, the old Garrison's Medical Officer's Quarters at Hastings and a major treasure; the old Smale School on Dalkeith Hill, an unusual Neo-Gothic mansion: the crumbling, neglected Eyrie; the hideously re-fenestrated Nightengale Children's Home, with its imprisoning metal louvres; the abandoned children's home at Newcastle Great House; the King's House Pavilion at Harrison College; St. John's Church and Sharon Church in serious need of funds; the beautiful, historic and symbolic Tyrol Cot, home of Sir Grantley Adams, and dozens more handsome but decaying treasures, in urgent need of rescue.

We have a unique architectural heritage in Barbados; from the humble slave huts in St. Lucy to the spectacular Sam Lord's Castle; from the more modest plantation houses, like Errol Barrow's birthplace to the most lavish, like Villa Nova; from the earliest mansions, St. Nicholas Abbey, Drax Hall and Warrens, to the nineteenth century

Codrington College from the hilltop (Codrington High School).
(Felix Kerr)

Codrington College, with cassock.
(Felix Kerr)

The Retreat, Harrison College.
(Felix Kerr)

classics like Highgate; from the tiniest chattel house in the shadow of Government House to that elegant mansion itself; from the uniquely Bajan suburban houses to the unusual Ilaro Court, Prime Ministers' Residence; the ancient stone churches, the warehouses, the town houses, the Garrison and Signal Stations, the mill walls, the lighthouses, the shops, the hotels, the schools and Codrington College, each and every type uniquely different from its counterpart in Jamaica or Trinidad or North America.

Perhaps the tide has turned. Even some of the neglected Government schools are at last receiving attention. The Retreat at Harrison College, for example, was restored on a shoestring, while the Neo-Gothic buildings on the Courtyard have had major work done. But perhaps the best Government effort, after years of total insensitivity to beauty and assault and rape of many a building in the name of repairs, is the restoration of the Geriatric Hospital on Beckles Road. These massive early Victorian mansion-blocks had become almost uninhabitable when the Ministry of Health stepped in with the only financially feasible solution, restoration. And the result, with the preserved coral stone arcades, cool Demerara windows and beautifully matching extension, is a resounding success, at a small fraction of the cost of new buildings. Dare we hope that this triumph will be repeated with sensitive restoration and modernisation of the Psychiatric Hospital?

The new interest in history has now sparked many restorations like Villa Franca at Hastings, the Seaview Hotel, the Virginian, Rus in Urbe, the Guard House Art Gallery, the beautifully handled

The Geriatric Hospital, Beckles Road, newly refurbished with great success and cost effectiveness.
(Henry Fraser)

DaCosta Mall, Broad Street – recently restored, with modern interior.
(Felix Kerr)

80 Treasures of Barbados

Francia Plantation House, St. George.
(Henry Fraser)

Barbados Mutual – then Bridgetown.
(Felix Kerr)

Barbados Mutual – now Collymore Rock.
(Felix Kerr)

A successful Post Modernist building, designed by Selby, Rose and Mapp, on Collymore Rock.
(Henry Fraser)

Brigade House, now to be Doctors' Offices, and many tiny cottages all over the island. The latest success is the DaCosta Mall on Broad Street, the old Colonnade with its ornate Victorian ironwork. And early in 1989 the restored Francia Plantation House in St. George joined the ranks of Villa Nova, St. Nicholas, Sunbury and Oughterson, in opening to visitors.

Traditional buildings also inspire new designs. Many urban buildings in Barbados have been uninspiring at best, if not downright ugly. (I don't have the courage to name them publicly.) Few achieve the brilliant success of the Barbados Mutual at Collymore Rock. But a new departure, following 30 years of largely pedestrian modernism, is Barbadian post-modernism in the hands of architects like Selby, Rose and Mapp, Gillespie and Steele, Robertson Ward, and Larry Warren.

The most successful, perhaps, has been the prominent Bajan interpretation of Palladio in pink, of cut coral stone and wood, the Kirby building on Collymore Rock. But more clever and subtle is the Mobil building in Aquatic Gap; and tourist-orientated buildings like Heywoods' Resort and Shakey's have been followed by the dramatic rebuilt Pepperpot, and the Aaron Truss building on High and James Streets, clearly inspired by its oldest neighbours.

Why *should* we save our old buildings? There are at least five obvious reasons:

- First, historic. We **must** have relics of our past – monuments, museums, which are the signposts of where we have been, and which help us to understand what we are today.
- Secondly, aesthetic. The beauty of a Villa Nova or a delicate chattel house, the strength and grace of a church are indisputable.
- Thirdly, emotional. Continuity of the landscape, and familiarity with our daily surroundings are now recognized to be invaluable binding forces, and sources of mental stability, strength and pride in the society. I also believe that respect for old buildings is integrally linked with respect for old people; caring for old buildings is a positive, creative force countering the wasteful, disrespectful, littering attitudes of our modern, throwaway society. This psychological justification is perhaps the most important of all.
- Fourthly, economic. Major restorations of historic buildings like the Barbados Light and Power headquarters, Lodge School, Harrison College, the Geriatric Hospital, the Waterfront Cafe and Shopping Malls in historic buildings like Da Costa's can save a small fortune and also save on foreign exchange while encouraging local craft skills and jobs and bringing positive benefits to tourism.
- My fifth reason is the total cultural impact of our built heritage. Much revolutionary modern building has been socially and culturally disastrous. Buildings which relate to the environment, to our sense of belonging, to their uses in our memory are important refuges in our lives. For instance here in Queen's Park, all kinds of social activities take place within and around the walls of a building 200 years old. Those walls and grounds, where cricket is played and the Police Band performs, where the grown-ups chat or reminisce and the children play by the African Baobab tree, epitomize the cultural continuity of the nation. We destroy such a heritage at our peril.

These walls and trees are treasures to be held in trust; they have touched our souls and shaped our lives. They are all *Treasures of Barbados*.

Country treasure.
(Henry Fraser)

References

Preface

1. Fraser, Henry and Hughes, Ronnie. *Historic Houses of Barbados*, 2nd edn, Barbados National Trust and Art Heritage Publications, Bridgetown, 1986

2. De Sola Pinto, Geoffrey and Phillips, Angheler Arrington. *Jamaican Houses – a vanishing legacy*, Phillips, Kingston, 1982

3. Lewis, John Newel. *Ajoupa: architecture of the Caribbean – Trinidad's Heritage*, J. Newel Lewis, Port of Spain, 1983

4. Watterson, Gerald G. *This old house: a collection of drawings of Trinidadian homes*, Paria Publishing Co. Ltd, Port of Spain, 1983

Chapter I

1. Ligon, Richard. *A True and Exact History of the Island of Barbadoes*, London, 1657, 2nd edn, London, 1673, facisimile reprint by Frank Cass and Co. Ltd., London, 1970

2. Campbell, Peter. Editor's Note to: Nicholas Plantation and some of its Associations, by E. M. Shilstone. In *Chapters in Barbados History*, The Barbados Museum and Historical Society, Bridgetown, 1986

3. Alleyne, Warren and Fraser, Henry. *The Barbados-Carolina Connection*, Macmillan Caribbean, London, 1988

4. Waterman, Thomas. 'Some early buildings of Barbados', *Journal of the Barbados Museum and Historical Society*, XIII, 140–148

Chapter II

1. Hoyos, Patrick. *Barbados, Yesterday and Today*, 2nd edn, Barbados National Trust, Bridgetown, 1990

2. Sheppard, Jill. *The 'Redlegs' of Barbados*, KTO Press, New York, 1977

Chapter III

1. Fraser, H., Carrington, S., Forde, A. and Gilmore, J. *A–Z of Barbadian Heritage*, Heinemann Caribbean (Publishers) Ltd., Kingston, 1990

Chapter IV

1. Campbell, Peter F. 'St. Ann's Fort and the Garrison', *Journal of the Barbados Museum and Historical Society*, 1975, XXXV, No.1, 3–16

2. Fraser, Henry and Alleyne, Warren. Preserving our heritage – historic buildings reborn', *Sunday Advocate*, 4 August 1985 – 10 August 1986

3. Schomburgk, Sir Robert. *The History of Barbados*, Longman, Brown, Green and Longmans, London, 1848 and Frank Cass & Co. Ltd., London, 1971

4. Buisseret, David. *Historic Architecture of the Caribbean*, Heinemann, London, Kingston and Port of Spain, 1980

Chapter V

1. Fraser, Henry and Hughes, Ronnie. *Historic Houses of Barbados*, Barbados National Trust and Art Heritage Publications, Bridgetown, 1986

2. Ligon, Richard. *A True and Exact History of the Island of Barbadoes*, London, 1657, 2nd edn, London, 1673, facisimile reprint by Frank Cass and Co. Ltd., London, 1970

3. Fraser, H., Carrington, S., Forde, A. and Gilmore, J. *A–Z of Barbadian Heritage*, Heinemann Caribbean (Publishers) Ltd., Kingston, 1990

Chapter VI

1. Alleyne, Warren. *Houses of the Barbados Parliament*, Barbados National Trust, Bridgetown, 1989

2. Alleyne, Warren. *Historic Bridgetown*, Barbados National Trust, Bridgetown, 1978

3. Waterman, Thomas. 'Some early buildings of Barbados', *Journal of the Barbados Museum and Historical Society* XIII, 140–148

4. Acworth, A. W. *Treasure in the Caribbean – A first study of Georgian Buildings in the British West Indies*, Pleiades Books Limited, London, 1949

Chapter VII

1. Schomburgk, Sir Robert. *The History of Barbados*, Longman, Brown, Green and Longmans, London, 1848 and Frank Cass & Co. Ltd., London, 1971

2. Alleyne, Warren and Fraser, Henry. *The Barbados-Carolina Connection*, Macmillan Caribbean, London, 1988

3. Collymore, Frank. *Barbadian Dialect 1955*, Barbados National Trust

Chapter IX

1. *Codrington College in the Island of Barbados* London, 1847

2. Fraser, Henry and Hughes, Ronnie. *Historic Houses of Barbados*, Barbados National Trust and Art Heritage Publications, Bridgetown, 1986

3. Fraser, H., Carrington, S., Forde, A. and Gilmore, J. *A–Z of Barbadian Heritage*, Heinemann Caribbean (Publishers) Ltd., Kingston, 1990

4. Hoyos, Sir Alexander. *Our Common Heritage*, Advocate Press, Bridgetown, 1953

5. Adams, Sir Grantley. Foreword to *Our Common Heritage*

Chapter X

1. Campbell, Peter F. *The Church in Barbados in the Seventeenth Century*, Barbados Museum and Historical Society, Bridgetown, 1982

2. Hill, Barbara, Ed. Fraser, Henry. *Historic Churches of Barbados*, Art Heritage Publications, Bridgetown, 1984

Chapter XI

1. Alleyne, Warren. *Historic Bridgetown*, Barbados National Trust, Bridgetown, 1978

2. Campbell, Peter F. 'Where Washington Stayed', *Barbados Advocate*, 7 September 1989

Chapter XII

1. Alleyne, Warren. *Houses of the Barbados Parliament*, Barbados National Trust, Bridgetown, 1989

2. Schomburgk, Sir Robert. *The History of Barbados*, Longman, Brown, Green and Longmans, London, 1848 and Frank Cass & Co. Ltd., London, 1971

Chapter XIII

1. Stoute, Edward. *Glimpses of Old Barbados*, Barbados National Trust, Bridgetown, 1985

Glossary

1. Gosner, Pamela. *Caribbean Georgian: The Great and Small Houses of the Caribbean*, Three Continents Press, Washington, D.C., 1982

Glossary

arcade: a range of arches. The best examples in Barbados are to be found in the Garrison buildings.

ballast bricks: English red bricks which came to Barbados in large quantities in the early days, as ballast in the tall ships, especially after abolition of the slave trade. The bricks were unloaded at Bridgetown or Speightstown and replaced with sugar or molasses. Hence many buildings of the early nineteenth century are of brick.

barge board: the strip of board along the edge of a gable, protecting the rafters and providing a neat finish to the roof. It was often highly decorative with an intricate fretwork design, and invariably painted white.

bell pelmet: the unique bell-shaped window-hood which evolved as the traditional Barbadian answer to the problems of keeping the rain out.

boiling house: the building near the sugar windmill, in which the cane juice from the mill was boiled to produce molasses and sugar.

bonding warehouse or 'Bond': the large, robustly built warehouses lining the Careenage and waterfront in Bridgetown, in which the sugar was stored, awaiting transfer by 'lighter' (row boats) to the ships in Carlisle Bay, before the building of the Deep Water Harbour or Bridgetown Port.

casement window: the sixteenth century window style; it opened outwards from the sides.

castellations, crenellations or battlements: a parapet with alternating indentations and raised portions as in a castle or fort. Although a prominent feature of Sam Lord's castle, they never caught on with the more typical, conservative Barbadian planter; Graeme Hall Great House was one of the few to copy Sam Lord's. It was demolished by Government in the 1960s but the elegant castellated mill wall still stands.

Chinese Chippendale: the combination of Chinoiserie (Chinese style and taste) and the elegant designs of Thomas Chippendale, eighteenth century British furniture and interior designer.

cooler window or Demerara window: the Demerara window was reputedly derived from Demerara, one of the provinces of British Guiana, now Guyana. It was essentially a full length window with a single, jalousied shutter or hood, hinged at the top and opened by pushing out with a long rod which was then stuck against the sill at the bottom. In the 'cooler window' the shutter was sometimes fixed at an angle or hinged, but had two triangular side fixtures, with a slatted shelf between them at the level of the window sill. On this ledge would have been placed the 'Monkey', an unglazed clay water jar, which was kept cool by the movement of air past the shaded window. (See Chapter III.)

coral stone: the white limestone covering most of the surface of Barbados. Easily quarried it was the preferred material for all the major buildings.

cornice: an ornamental moulding along the top of a building, usually of plaster but sometimes of bricks.

Demerara window: see *cooler window.*

dentil: a decorative cornice in which alternating bricks project to produce a tooth-like pattern.

dripstones: the traditional water purification system in which water for drinking was passed through two large pots carved of coral stone. (See Chapter III.)

Dutch gable: an elegant gable end with curved sides, sometimes multicurved or curvilinear and often with a small pediment on top.

eaves: the underside of an overhanging roof.

fanlight: a semi-circular or segmental window over a Georgian or Regency door with radiating bars like sun-rays between the panes of glass.

finial: a sculpted or carved ornament, usually of stone at the top of a gable, corner of a building, balustrade etc.

fishpond roof: a roof designed with a tank at the centre to collect rain water. (See Chapter III.)

front house: the first or front section of a multi-unit chattel house. This part was usually the best room or sitting room. (See Chapter II.)

gable: the triangular, upper part of the wall at the end of a pitched roof (or gable roof). It normally has straight sides, but there are many variations, for example curved, curvilinear, multicurved and Dutch, hipped (where the upper portion slopes back and the roof is called

a half-hipped roof).

gable window: A window placed above the roof line of a pitched roof, in the same plane as the wall, but with a little roof of its own; distinguished from a dormer window which is set further back from the wall.

gallery: in Barbados this came to mean specifically the long room on the outside of a building, usually at the front and enclosed with jalousie windows. A similar room open on the outside or with posts and a rail would be called a verandah; but sometimes the word gallery is used loosely whether there are posts, arches, jalousies or the classic 'front gallery' arrangement of alternating jalousies and glass sash windows.

Georgian: the architectural style which evolved in England from the Palladian style introduced by Inigo Jones; although more restrained than the original it expressed the same classical principles of symmetry and harmony of composition. Since it was in this period, in the reigns of the English Kings George I, George II and George III, that the Caribbean sugar trade was prospering, Georgian architecture had a profound influence on Caribbean architecture, and the term Caribbean Georgian has great validity.[1]

Gothic/Neo-Gothic: the church architecture from the twelfth to the fifteenth century in Western Europe – The architecture of the vertical, with its pointed arches and arcades, flying buttresses, vaulted roofs and lofty towers and spires. In the Gothic or Neo-Gothic revival, there was a romantic evocation of medieval times.

gutterhead: the structure at the top of the downpipe into which rain water from the roof flows first, to be directed into the vertical guttering or down-pipe itself. Some had the date of the building marked on them but few remained. Some too were made of cast-iron and were elegantly ornamented.

hip-roof or hipped roof: a roof which slopes down on all four sides. The hip-roof lent itself to the tray ceiling (See *tray ceiling*).

hurricane shutters: all major buildings had strong solid wood hurricane shutters. They were usually on the inside of the windows and doors, folded back against the door jamb when not in use; they were elegantly panelled on the surface that was seen. When closed they were kept securely in place by a strong wooden bar three or four inches thick which slotted into deep holes on either side of the door or window.

Jacobean: the English architectural style which followed the Tudor or Elizabethan and preceded the Georgian period. It was characterized by a reduction of the fussiness of the Elizabethan period and by a strong continental influence, especially that of the Dutch.

jalousie, jalousie window: a window or window shutter built of horizontal slats, usually of wood, which slope and overlap so as to keep out rain and sun but let in air and modest light. Some were adjustable.

lathe and plaster: this technique was used for ceilings and light, non-weight-bearing walls, where thin lathes an inch or two wide were plastered over to form a smooth surface. The space between the lathes was stuffed with anything, from corn cobs to wood shavings or stones or a mixture of all. Sometimes a variety of non-sweet (wild) cane was used for the lathes.

Modernist: the architecture which expresses the spirit and technology of the twentieth century.

mouldings: ornamental contours on cornices, doors, panelling, etc.

mounting blocks: a structure two or three feet high built in a pair at the bottom of the entrance staircase to a great house or other major building, for mounting and dismounting a horse.

Palladian: the architectural principles and style of the Italian architect Andreas Palladio, whose evocation of classical designs and his own prolific designs, writings and buildings have perhaps had a greater influence on Western architecture than any other architect of all ages. Although the only major building in Barbados which is entirely 'Palladian' is the twentieth century masterpiece Heron Bay, designed for Ronald Tree in 1947, there is a strong Palladian spirit in the Barbadian suburban villas (see Chapter VIII) and in a number of great houses, particularly at Colleton House in St. Peter.

Palladian window, or Venetian window: one of the hallmarks of Palladian design was the elegant window, with three lights and an arch over the central one. It was usually the main or only window in a part of a facade. (See Alleynedale.)

parapet: any kind of low protecting wall but in Barbados it applied particularly to the parapet roof, where the wall extends above the roof line, so that the roof ends within the wall and is

thus protected from hurricane winds.

piano nobile: the main rooms of the house arranged on the upper floor. Essentially a Palladian design, with the reception rooms reached by an ornate double staircase, and with the service rooms below, this style became the standard for the Barbadian suburban villas.

plaster ceilings: the technique of rendering highly decorative ceilings in plaster sculpture was brought to Barbados by a master craftsman, Rutter, who worked on the ceilings of Windsor Castle. His first commission was Sam Lord's Castle. He then set up shop in Barbados and executed ceilings on many great houses, although only a few survive (Highgate House, Verdun Wildey House and Canefield House).

quoins (from the French 'coin'): the prominent stones at the corner of masonry buildings laid so that their faces are alternately long and short; they are often used around doors and windows as well. Quoins may be rusticated with deep grooves between the stone blocks, or of plaster where they are actually simulated on the surface of the walls.

recessed panel: a portion of wall or wooden surface which is recessed below the surrounding surface or frame.

rubble wall: the traditional simple form of masonry building with roughly hewn coral stones of all shapes and sizes, commonly not dressed at all or minimally so, employing large quantities of lime mortar. Other ingredients (egg, molasses, clay etc.) were sometimes incorporated in the mortar. Sometimes in coursed rubble the stones were layed in courses like bricks and the surfaces roughly dressed. Courses tended to be of varying widths and the hardest, fossilised coral stones often selected for outer walls, fortifications etc. (See the restored east wall of the Light and Power headquarters at the garrison.)

sash window: a window built with a frame with grooves, within which the glazed parts slide up and down, supported by ropes on pulleys and counterpoised with weights.

shed roof: the hindmost unit of a chattel house, so called because it is smaller than the outer units and is covered with a flat, sloping roof. It would usually accommodate the kitchen and an informal eating area. In its simplest form it was often at ground level with a dirt floor, while the front of the house or front two units were elevated on stone blocks. It is usually the first part of the house to be 'improved', being replaced with a kitchen and indoor bathroom of concrete blocks.

slave huts: Simple, rather crude stone huts which survive in a few isolated parts of the country and are believed to be former slave huts. (See Chapter II.)

single house: the traditional house form devised in Charleston, South Carolina, frequently attributed to Barbados.

turned posts: wooden posts shaped or turned on a lathe so that they are circular in cross-section.

tray ceiling: the roof was ceiled at a level of one or two feet above the top of the walls, to provide better circulation of air and hence a cooler room. The resulting appearance was that of an inverted tray with sloping sides, of the type used traditionally by hucksters (hawkers).

valley gutter: the gutter running in the valley between two adjacent gable roofs. Both in large and small houses in Barbados, roof designs were based on a series of small roof sections rather than a large single roof – perhaps of benefit against hurricanes.

veranda or verandah: from 'varanda' in Hindi meaning a balcony. A covered area along the front or sides (often all three) of a building, usually with supporting posts of wood, sometimes with a rail or balustrade. It is believed to have been introduced by the colonial British, who borrowed it from India. If arcaded, it was still called the veranda or even the gallery (see *gallery*).

vernacular architecture: the architectural forms native to the country – usually less sophisticated styles and devices but often unique and indigenous to the country.

yam cellar: although yams might have been stored in any plantation outbuilding, there was usually a storeroom for 'ground provisions' (yam, potatoes, edoes etc.) in the cellars under the plantation manager's house. These cellars were often partly subterranean, with a floor of natural rock; being much cooler than anywhere else on the plantation they were used as a 'cold room'; they were also under the watchful eye of the manager and his watch dogs.

Index

Note: Numbers in italics refer to illustrations.

Aall Gallery 36
Adams, Sir Grantley 58, 73, 77
Adams, Tom 58
Afro-European settlement 60
Alexandra School 45
Alexandra's Night Club 33
All Saints Church 64
Alleyne School 57, 71
Alleyne, Sir John Gay 3, 57, 71
Alleynedale 6, 28, *29*
Alleynedale slave hut 7
Andromeda Tropical Gardens 59
Aquatic Club 65
Arches, Georgian 3
Arches, Roman 20
Architecture, Dutch 2
Architecture, Georgian 13, 31
Arlington *44*, 45
Articles of Agreement 71
Atlantis 67
Austin, Miller 17
Ayscue, Sir George 16, 44, 71

Bacon's Castle 2
Bagatelle 31
Bajan parapet 52
Bank Hall 28, 54, 59
Bannochie, Iris 59
Barbadian Adventurers 2
Barbados Society of Arts and Crafts 28
Barbados Defence Force 23
Barbados Labour Party 39, 58
Barbados leg 65
Barbados Light and Power Company 20, *21*
Barbados Museum 5, 18, 20, *22*
Barbados Museum and Historical Society Journal 2
Barbados Mutual 57, *80*
Barbados National Trust 20, 34, 59
Barbados National Trust Headquarters *52*
Barbados Workers Union 73
Barbadosed 7
Barbara Hill 62
Barclay, James 57
Barrow, Errol 27, 55, 73, 77
Bath houses 50
Bay Mansion 27, *28*, 31, 33, 62, 74
Bay Street 39, 50
Beckles, John 74
Beckwith Place 74
Beckwith, Sir George 74
Belfield 57
Bell pelmet 9
Bell, Philip, Governor 60
Belleville 31, 51, *52*, 54
Belmont House 51
Belmont Road 51
Belmont Road villas 51

Berbice chairs 16
Berringer, Benjamin 1
Betsy Austin 65
Bishop Coleridge 62
Bishop Mitchinson 73
Black Rock 31
Blocks A, B 24
Block B 20
Blocks A, B and C 31
Boatyard 38, 50
Book Place, The 58
Bourne, London 38
Bovell, John R. 59
Bow front 33
Boys' Central School 59, 73
Brancker, J.E.T. 73
Brathwaite, Chrissie 73
Breadcart *15*
Bridgetown 35
Brigade House 24
Bristol 44
Bromefield 25
Bulkeley 28
Bulkeley Great House 17, *29*
Bush Hill House 19, 24, *65*, 66
Bushe Experiment 73
Bussa 59, 72
Buttals 31
Buttals House 30
Byde Mill 28, *29*

Cabbage Tree Hall 28
Calvary 63
Calvary Moravian Church 42
Campbell, Peter 2
Canefield House 33
Captain Crofton 65
Careenage 43
Caribbean Tourism Research Centre 53
Carlisle Bay 19
Carlisle Bond 42
Carlisle View *39*
Carlisle, Earl of 69
Carnegie Free Library 42
Carolinas 2, 45
Carter, Dr. Bertie 33
Carter, Harcourt 18
Cathedral 42
Cave Hill 6
Cave, Stephen, Lieutenant-Colonel 5
Chamberlain Bridge 36
Chapels of ease 62
Chapmans 15
Charles Duncan O'Neale Bridge *36*
Charles Fort 19
Charles I 44
Charles II 2, 71
Charleston 38, 45
Charter of Barbados 71
Chattel house 2, 54
Cheapside 49
Chelsea House 18

Chenery, Thomas 59
Cherry Tree Hill 5
Child Care Board 39
Chinese Chippendale 4
Church Street 47
Churches 60
Clarence Hotel 37, 65
Clarke, Sir Charles Pitcher 59
Clifton Hall 2
Coal pot 17
Coconut Fort 44
Codd's House 38, 72, 73
Codrington 25, 56
Codrington College 25, 55, *78*
Codrington, General Christopher 27, 28, 55
Coleridge, William Hart, Bishop 72
College Plantation 27
Collymore, Frank 47, 59
Colonel Alleyne 44, 71
Colonnade 81
Combermere School 59
Confederation Riots 16, 73
Consett 56
Consett House 56
Consett Plantation 27
Consett Plantation great house *26*
Cotton Tower 23
Court House 38
Courteen, Sir William 69
Crane Hotel *66*
Cromwell, Oliver 44, 71
Cropover 18
Crumpton Street 54
Culloden Farm 31, 55
Cunard Gallery 36

Dacosta Mall 79
Dacosta's Warehouse *41*, 42
Dalkeith Hill Church 63
Demerara windows 39, 79
Democratic Labour Party 73
Democratic League 58
Denmark Fort 44
Double houses 28
Dover Fort/Castle 23, 44
Drax Hall 2, 25, *26*, 31, 77
Drax Hall staircase *27*
Drill Hall 19
Dripstones 17
Dry Dock 42
Dutch influence 36

Eastmont 2, 17
Eden, Sir Anthony 34
Edghill, James Young 57
Education Commission 73
El Sueno 53
Empire Cricket Ground 59
Empire Theatre 77
Emtage, Bill 59
Enfield House 15
Engineers' Pier 65
Erin Hall 33

Ernest Deighton 'E.D.' Mottley 42
Exchange, The 38, 50, 77
Executive Committee 73
Eye Hospital 22
Eyrie, The 15, 57, 77

Fairfield Plantation 5
Farley Hill 5, 23, *32*, 33, 76
Farnum, William 58
Ferdinando Paleologus 63
Ferdinando Paleologus, tomb *62*
Fireplaces 2
Fish pond roof 15, 57
Fisherpond 18
Fitz Village *11*
Fontabelle 50
Ford Map 15
Forts 44
Fountain Gardens 76
Francia Plantation House 18, *80*
Fraser, James 57
Frenches *26*, 27
Friendly Hall 76
Friendship plantation 38
Front house 9

Gable 2, 9, 54
Gables, Dutch 2
Gale, Valence 59
Garden, The 27, 55
Garrison 31, 67
Garrison Savannah 19
Garrison Theatre 20
Garrison, St. Ann's 19
General Hospital 20
General Vaughan 22
Georgian 2, 23, 28, 32
Georgian Palladian 20
Geriatric Hospital 57, 79
Glendairy Prison 58
Gothic 61
Gothic revival 62
Government House 33, 38, 70, 76, 79
Governor MacGregor 72
Governor Robinson 36
Grand Barbados 65
Graveyard 6
Great Escape 31, *52*
Great Pilgrim House 70
Greaves, Sir Herbert 58
Green Hill *8*
Greenidge, C.J. 57
Greenland 4
Grenade Hall 23
Guard House Art Gallery 79
Gun Hill 23
Gun Hill Signal Station *23*
Guyana 16
Guyana leg 65

Hackleton's Cliff 62
Halton 27
Halton Great House *32*

Hannah's Village 6
Harford Chambers 2
Harmony Hall *31*, 73
Harrismith 34
Harrison College 81
Hastings 20, 31, 50, 53
Hawley, Henry, Governor 69, 70
Haynes, Edmund 25
Haynes, General Robert 31
Drax, Henry 59
Herb garden 2
Heywood's Battery 44
Highgate 23, 32, 79
Hinds, Percy 50
Hip-roof 9
Holborn 70
Holborn House 38, 76
Holetown 60
Holetown monument 69
Holetown Police Station 60
Holy Cross 64
House of Assembly 70, 73
Hurrican Janet 50
Hurricane Gilbert 16
Hurricane Hugo 16
Hurricanes of 1780, 1831 31
Hutson, Sir John 73

Ice House 76
Ilaro Court 79
Indentured servants 6
Independence 73
Indian Pond 30
Indian River Monument 69
Iron Barracks 20, 24
Island Inn, The 67

Jacobean 2
Jacobean staircase *27*
Jalousied gallery 51
Jalousies 9
James Fort 60, 72
James I 2
James Street Methodist Church 63
Jamestown 60
Joseph-Hackett, Daphne 58
Joe's River Mortuary Chapel 64

Kendal 31
Kensington 19
King Ja Ja 58
King's House Pavilion 77
Kingsley Club 67

Law Courts 38, 73
Leacock slave hut 6
Legislative Council 73
Liberal newspaper 57
Liberal Party 72
Light and Power building 24
Ligon, Richard 1, 25, 44, 45
Lion, Gun Hill 23
Lions' Den for the North 45
Little Bristol 44
Lodge School 56, 81
Lower Carlton *10*
Lynton 39

Mace 74
Main Guard *19*, 24
Malvern 17, 18, 28
Manning, Sam 51
Maple Manor 53
Marie-Louise, Empress of France 5
Marine Gardens 53
Marine Hotel 66
Marlhill 70
Marshall Hall 42, 77
Marson, Victor 67, 68

Martineau House 39
Martineau, J.A. 39, 58
Masonic Hall 77
Melville, Keith and Angela 17
Mermaid Tavern 71
Mervue 53
Methodists 63
Mike's Place 47
Military Hospital 50
Military Prison *22*
Mobil building 81
Moll's Alley 40, 41
Moncrieffe 23
Monkey 18
Moore's Hill 6
Moore's Hill slave hut 7
Moravians 63
Morgan Lewis Mill 5, 77
Mottley House *57*
Mottley, Ernest Deighton 'E.D.' 77
Mount Tabor 63
Mount Tabor Church 25
Moyne Commission 73
Musson House 42

Nancy Clarke 65
Napoleon Bonaparte 5
National Trust Restoration Award 51
Naval Dockyard 65
Needham's Point 19
Nelson, Horatio 43
Neo-Gothic 35, 61
New Burnt District 35, 73
New Town Hall 73
Newcastle 31
Newcastle Great House 77
Nicholas plantation 1, 6
Nicholls building 2, 36
Nightengale Children's Home *56*, 77
Nightengale Home *57*
Nightengale, Dr. William Henry 57
Noel Roach and Sons Pharmacy 45, *46*, 47

O'Neale, Dr. Charles Duncan 39, 58, 73
Ocean View Hotel 67
Odle Frank 68
Odle, Peter 68
Oistins 71
Old Town Hall 42, 73
Olive Blossom 69
Orange Fort 44
Oughterson 2

Palladian 9, 28, 31
Palladian villa 50
Palladio, Andreas 20
Palmetto Street 41
Parade View 20, *50*
Parapet roof 31
Parkinson, Rawle 59
Parliament 69
Parliament Buildings 35, 43, 73, 74
Pavilion 20, *21*, 23, 24, 77
Pavilion Court 20, *21*, 50
Pavilion Road 59
Payne, Ivan 44
Paynes Bay 12
Pedimented porch 9
Pelmets 54
Pepperpot 81
Pilgrim Place *9*
Pinckard, Dr. George 72
Plantation great house 15, 25
Plantation houses 25
Polgreen, Rachel Pringle 65

Pope-Hennessy, Sir John, Governor 16, 73
Porches 54
Porters 4
Post Modernist *81*
Post Office and Library 45, 46
Powell, Captain John 69
Power, Noble 58
Prescod, Samuel Jackman 72
Prince William Henry 65
Principal's Lodge *26*, 27, 56
Prison 20
Privy 2
Providence 63
Public Buildings 35, 42, 74

Quartermaster's Store 20
Queen Street 44
Queen's College 58, 59
Queen's Park 81
Queen's Park House *20*, 22, 59, 73

Railway 66
Rebellion of 1816 72
Redlegs 6
Reeves, Sir Conrad 57, 73
Retreat, Harrison College *78*
Risk 6
Roebuck Street 40, *70*
Roebuck Tavern 70
Ronald Tree House *52*
Rosemount 76
Round House 22
Royal Navy Hotel 65
Rum Store 67
Rus in Urbe *53*, 54

Sailmaker 36
Sam Lord's Castle 10, 33, 50, 67, 68, 77
Samuel Copen 36
Samuel Jackman Prescod 57
Sash windows 2, 16
Savannah 20
Savannah Club *20*
Savoy 39, *40*
Schomburgk, Sir Robert 23
Schooners 44, 48
Scotland District 5
Scott, Sir Winston 50, 73
Seaview Hotel 24, 67, *68*
Seawell 76
Senate 73
Sessions House 70, 72
Shakey's 81
Sharon Moravian Church *63*, 77
Shed roof 9
Shrewsbury 63
Signal Stations 23
Single house 38, *44*, 45
Six Men's Jetty 48
Skeete, Lee Harford 36
Slave huts 6
Smale School 77
Smith and Oxley building 53
Solidarity House 4, *31*, 73
South Carolina 38
South Point Lighthouse *76*
Speight, William 44
Speightstown 2, 23, 44
SPG 56
Spirit Bond *76*, 77
Spirit Bond and Customs House 42
Spry Street 41
St. Ann's *64*
St. Ann's Fort/Castle 19
St. Ann's Garrison 24
St. George's Church 61
St. James Parish Church *60*

St. John's Church 62, *63*, 64, 77
St. John, Bernard 17
St. Margaret's Church 64
St. Mary's Church 41, 42, 60, *61*, 62
St. Michael's Almshouse 59
St. Michael's Cathedral 41, *61*
St. Michael's Church 60
St. Michael's Row 51
St. Nicholas 31
St. Nicholas Abbey *1*, 2, 6, 25, 57, 77
St. Patrick's Cathedral 64
St. Peter's Church 45, 64
Stafford House 24
State House 72
Steele, Joshua 28
Stepney House 15
Stone Barracks 20
Stratford Lodge 58
Strathclyde 53
Suburban house 13, 49
Suburban villa *11*
Sunbury 6, *16*, 28
Sunbury Plantation House 15
Swing Bridge 36
Synagogue 38, 73

Thomas, Nick and Sally 18
Town Hall and Jail 72
Town Hall Jail 38
Trafalgar Square *35*, 43, 72
Trinidadian House *53*
Tufton, Sir William 69
Turner's Hall 76
Turner's Hall Wood 1
Tyrol Cot *58*, 77

Ursuline School 76

Vaughan, H.A. 73
Verdun 33
Vestry Hall 42, 77
Victorian reading chair 5
Villa Franca 15, *50*
Villa Nova 6, *25*, 33, 77
Virginian, The 20, 24, 31, *50*

Wakefield 33
Ward, Erskine 73
Ward, Sir Deighton 16
Warehouse Restaurant 47
Warrens 25, 28, 31, 33, 77
Washington, George 19, 24, 65
Waterfront 41
Waterfront Cafe 42, 47, 76
Wattle and daub 6
Weatherhead, Bobby 67
Welches 31
Welches plantation *11*
Welfare Department 20
West India Barracks 20
West Indian newspaper, The 57
West, Benjamin 61
Westgate 15
Westmacott, Sir Richard 63
Westmoreland *8*
White, Golde 59
Wickham, Clennell 59
Wildey 76
Wilkinson, Captain Henry 23
Willoughby, Lord Francis, Governor 2, 44, 71
Wolverstone, Charles, Governor 69
Women's Self Help 76
Woodville 50
Worrell, Sir Frank Maglinne 59
Worthing 53

Yam cellar 17
Yarico's Pond 31